Figure Drawing
Workshop

Figure Drawing

WATSON-GUPTILL PUBLICATIONS/NEW YORK

Workshop

ALLAN KRAAYVANGER

Senior Acquisitions Editor: Joy Aquilino
Edited by Laaren Brown
Designed by Patricia Fabricant
Graphic production by Ellen Greene
Text set in Weiss

Copyright © 2003 by Allan Kraayvanger
First published in 2003 by
Watson-Guptill Publications,
A division of VNU Business Media, Inc.,
770 Broadway, New York, N.Y. 10003
www.watsonguptill.com

Library of Congress
Cataloging-in-Publication Data

Kraayvanger, Allan.
 Figure drawing workshop / Allan
Kraayvanger.
 p. cm.
Includes index.
 ISBN 0-8230-1700-1 (pbk. : alk. paper)
 1. Figure drawing--Technique. I. Title.
NC765.K68 2003
 743.4--dc21 2003000942

Manufactured in the United States
of America

First printing 2003

1 2 3 4 5 6 7 8 9/09 08 07 06 05 04 03

This book is dedicated to the one who is responsible for all that beauty out there, who opened my eyes to it and gave me a lifetime of pleasure trying to draw it.

Contents

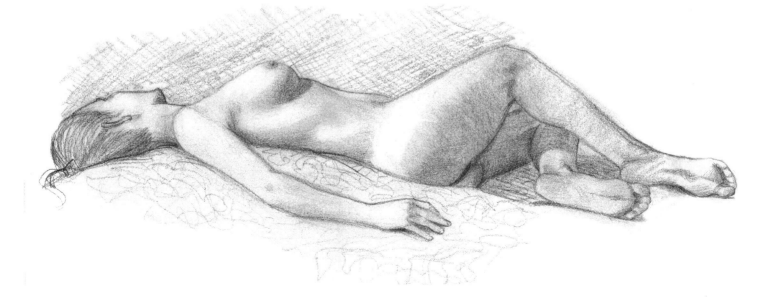

Preface

"If you can draw the figure, you can draw anything." Most artists accept this statement as gospel, yet in spite of diligent lifelong practice, most of them have serious trouble when they try to draw the figure with any conviction.

Many artists can draw inanimate objects beautifully. They have a great sense of design and color and flawless taste in organizing their compositions on paper or canvas, but when confronted with the figure, they are stopped cold.

Is figure drawing really that much harder than drawing other things? In theory, if you can draw anything else in front of you, you

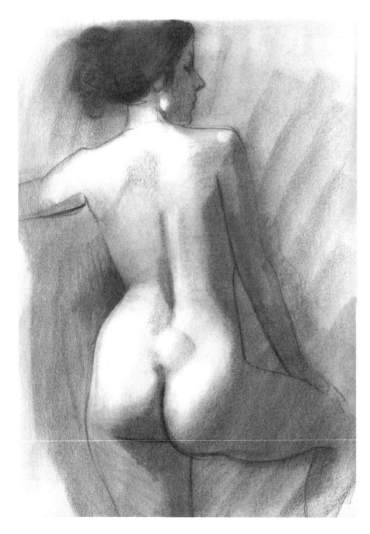

should be able to draw people just as well. But it simply doesn't work that way. Animate subjects require much more study and skill to portray as living things made of muscle and bone.

In art, as in most things, we reach a certain level of accomplishment fairly early. Then, as things get harder, improvement comes slower and stops or even regresses without a disproportionate expenditure of effort. I know artists who have been drawing steadily for more than forty years with little or no improvement in their figure drawing skills. I was one of these artists. After I had reached a level where I could earn my living with art, I doubt that much, if any, improvement came over the next forty years.

I learned more after retirement in the evening figure drawing workshops than I did in all those preceding years. At last I had time to experiment to see if I could find the problem and correct it. Something seemed to be missing from my earlier training. Finally I had found it, and a whole new world of seeing things has opened up for me. I wish I had learned these things earlier. It seems easy now to watch other artists struggling and to see what is holding them back.

This book represents my best attempt at sharing this information with those who are interested in breaking out of the mental traps that they have put themselves in over the years—especially the younger artists who wish to avoid these traps so they can make reasonable progress as long as they put out the required effort.

The most important thing I learned is that it is not necessarily true that if you draw a lot, you will automatically get better. The fact is, if you do it wrong, you will get better at doing it wrong. The longer you have been doing it that way, the harder it gets to learn to do it right. You need a fairly prolonged early period of developing the proper seeing habits so that they become automatic before you can do

anything meaningful consistently. Of course, you will never arrive at the point where you can do it right every time, so the struggle never ends.

I am giving a fresh viewpoint here, and I am using only my own drawings to illustrate my points. These drawings were all done from the model under time constraints, and the temptation is strong to fix those of them that I am unhappy with—but I feel it is better to show the bad ones as well as the better ones so that you can see that we all have to struggle with the same problems. Even the masters turned out more mediocre work than we realize because we see only their best examples.

So don't get discouraged when you have a bad day. Consider your failures to be learning experiences. Above all, remember that this is only one way to do things. I know these ideas work, but there are many other ways that work, too. The goal of this book is to get you to see and think along lines that will guarantee progress. Avoid mindlessly drawing from the model with no specific goal other than a vague idea that if you keep drawing, something good will come of it.

This book is about learning to draw from the live model. I am absolutely convinced that this practice is the best way to learn to draw anything. It is the foundation for the growth of any aspiring artist. If you get the basic essentials down right, the finishing process is easy. Almost all of the problems the figure draftsman confronts are in the earliest stages of the drawing. If the basics are wrong, the drawing and the artist will never progress.

The past few years of fairly intensive study have convinced me that several things must be done in order to make significant progress in drawing the figure. Developing the discipline to draw exactly what you see before you attempt the more difficult creative approaches is

high on the list. This is the study that many art schools have mistakenly eliminated, or at best minimized, in order to protect the "fragile" creative spirit of their students. I am hoping to reintroduce this most important component of learning to draw to you in this book. Also important is the ability to see and think in simple flat shapes before you get all tangled up in the three-dimensional details of your subject.

These two things represent the major goals of this book, and if you concentrate on them rather than simply drawing from the model without a specific focus during your figure drawing sessions, you will surprise yourself with your progress.

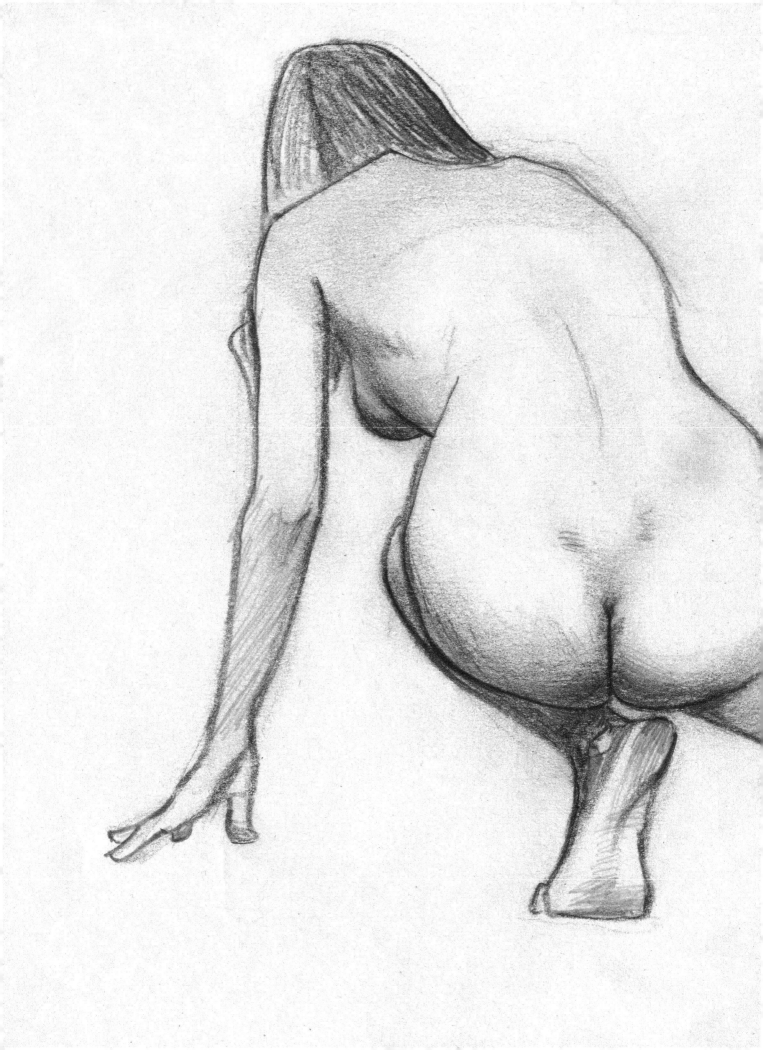

Preparing to Draw

In this chapter, we take a look at the essentials of figure drawing: materials, basic techniques, and preparing to attend a life drawing class. This is the starting point for every artist—and every artist will return to these important basics again and again in the course of a lifetime of drawing.

Basic Materials and Techniques

In figure drawing, there is a wide choice of materials available. Anything capable of making a mark on paper can be considered a possibility. Centuries of experience have produced several basic classical tools, which remain the artist's overwhelming choice for drawing, and we will focus on these.

As you gain experience, you will find that you are more comfortable with certain tools and favor them, but until you have some experience with all of them, do not limit yourself to any one. I do not recommend using the pens, markers, or painting materials at first, because they just add an additional set of factors for you to cope with. If you master these basic tools first, you will find that the other ones are simply an extension of the knowledge you will have gained.

The four basic tools we are concerned with here are first, graphite based, such as pencils; and then charcoal; wax based, such as Conté crayons; and chalk based, such as pastels.

The graphite-based tools include simple drawing pencils and graphite sticks, which are solid graphite wrapped in a paper or plastic. Both drawing pencils and graphite sticks come in different grades of softness, ranging from 9B (the softest) to 9H (the hardest). Forget the H grades; you can try them if you want, but they are all too hard for our purposes. Graphite gives you beautiful soft grays and is smooth and easy to use. Unfortunately it does not offer a deep, rich black, and graphite drawings can have an unpleasant shine when viewed at an angle. Still, the graphite pencil is the most familiar and popular of all the drawing tools; and it can be used to create the full range of artistic expression. And as an extra bonus, pencils are easy to take with you because of their protective wood case! However, because the point of a pencil is so fine, and because it is so easy to sharpen a pencil, developing artists may feel compelled to draw on a too-small, too-detailed scale.

Charcoal comes in several varieties: natural vine, willow, and compressed sticks. It also comes in several degrees of softness. The harder ones are also generally less desirable for our use. Charcoal offers a full range of values, from the richest blacks, with compressed charcoal, to the most delicate soft grays, from the natural charcoals. Probably the most versatile medium of them all, it is especially great for putting down big soft tones to work into. Charcoal is easily erased or wiped out and altered as you work.

Conté crayons come in square sticks and in pencil form. Both the sticks and the pencils are available in several degrees of softness. The chief problem with Conté is that it is harder to erase than pencil, charcoal, or chalk; but Conté crayons more than make up for this by being somewhat less inclined to smear. Because of this it is not as messy to work with as charcoal. In the proper hands, Conté crayon can be used to create incredibly beautiful work. It comes in black, white, and several classical brown tones reminiscent of Old Master drawings.

Chalks, or pastels, come in a huge variety of colors. While the temptation is strong to use them all, I recommend that you limit yourself to the blacks, grays, or browns while studying the ideas in this book. They also come in varying degrees of softness. The harder sticks, such as NuPastels, are probably the easiest to use as you begin figure drawing. The working qualities are similar to charcoal.

All of these tools offer both linear and tonal possibilities depending on how they are held and used.

The only reasonable way to learn to use your drawing materials is to use them. All the words in the world would not be equal to one hour spent playing around with them. Here is the quickest, easiest way to get started: Get some graphite pencils in HB, 2B, 4B, and 6B, plus a couple of soft graphite sticks from your

art-supply store. Also get a few sticks of willow or vine charcoal, some compressed charcoal sticks, a couple sticks of Conté crayon, and some soft charcoal pencils. You also need an eighteen-by-twenty-four-inch pad of newsprint paper, as well a kneaded eraser, a chamois or a soft rag, and maybe a couple of tortillions (these are rolled paper sticks, used for smearing and blending tones). If you can't find all these materials right now, don't worry; a couple thick soft pencils will get you started, and you can add the rest as you go along. Now let's get started.

Simply play with your materials. Draw light lines; dark lines; lines with changing pressure; long flowing ones; short jabbing ones; searching lines that seem to be looking for the right place to settle; wobbly, uncertain ones; and any other kind of lines that comes to mind. Do your lines boldly, quickly, and smoothly. Now try smudging them with your finger, rag, chamois, or tortillion, and really look at the results so you will be able to remember them. Try out different grips to hold your tools—you can use anything that is comfortable and gives you the kind of control you want. You can sharpen your Conté crayon if you like, and use it like a pencil. Play around with all of these tools, noting the various lines, textures, and tones you get. Do this until you feel comfortable with them. Use up the whole pad or more. It will not be long until you find a couple of these tools that really feel right for you.

There is a huge choice of excellent papers to work on. In the beginning I strongly advise you to work on an eighteen-by-twenty-four-inch pad of relatively inexpensive newsprint paper, or even brown kraft paper. Both newsprint and kraft paper actually have great surfaces to work on with all of our basic mediums, and you will be less inhibited to work freely when it costs you less to make a mistake.

Later, as you gain confidence and experience, you should move on to better grades of

Hold your tool closer to the point for greater control. Hold it farther back for looser, freer lines. The grip shown here gives you better control for finer, tighter details, because you can use simple finger movements when you need them. But to keep things free, you need to use your whole arm while drawing.

Hold your tool flat to the paper for broader lines and tones. I do most of my drawings with this grip; I find that it gives me much freer and more spontaneous results. Experiment to find your favorite grips.

paper. Search for those that are best suited to your temperament and are more permanent. You will find that the many different surfaces and textures produce completely different results. Try everything that looks interesting to you, even papers that were made for other purposes, such as wrapping papers. Although better materials often give better results, there is no law saying that you must use papers, or anything else to work with, made specifically for artists.

These first experiences with materials and techniques will give you useful background as you develop as an artist. But even as you become more accomplished, make it a point to check out something new periodically. Soon it may be time to try brushes of different shapes and sizes with gouache or watercolor. Then you will need a heavier paper to work on to avoid wrinkling. Later you may be ready for a marker pen. Use your favorite tools, but don't forget to keep on experimenting with new things.

Line Control

A great way to get the feel of your tools, and to develop greater control, is to scatter dots around a fairly large sheet of paper randomly, then pull smooth, long, flowing lines down to meet the dots. Take charge! Come at your dots from all angles. Do not make choppy, indecisive lines. Make some of your lines curved, some straight, and some *S* curves. Do fast lines and slow lines. Find the speed that gives you the best control. Do thin lines and broad lines. Make them darker and lighter.

This exercise forces you to be aware of the dot already on the paper as you pull your line down to meet it. This is exactly the attitude you should develop as you draw. You need to be aware of and see the work you have previously placed as you add new lines so that you can be comparing shapes, sizes, and line directions as you work.

Start this exercise with a soft 2B graphite pencil, but eventually try it with all your tools, using the two grips at various positions.

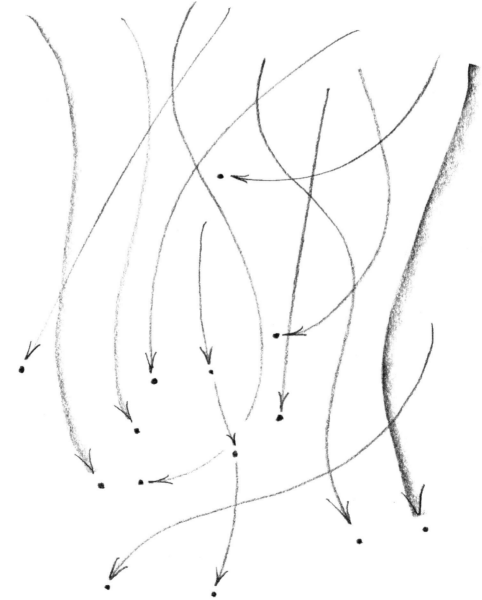

Value Control

In this book, what I mean by value is the degree of lightness or darkness of a thing, whether it is white, black, or any gray in between.

To the right is a scale of ten values (if you include the white paper). Ten is just about the upper limit of the number of values you can differentiate with your drawing materials.

Try to match these values, using all your different drawing tools. Notice that the graphite pencils and the vine or willow charcoals cannot match the black, so they are limited to producing values at the dark end of the scale. As you experiment, you will also note how difficult it is to get the really delicate grays with some of the mediums.

You will occasionally use all of these values in a finished drawing, but you will soon find that, especially in sketching, you will get more clarity and power in your work if you limit your selection to five values, or approximately every other step in the scale. But remember—you do not need to match these values exactly. Limiting your work to about five values means that you are creating more differentiation between the values, so they will read more easily. Obviously there will be times when you need more subtlety, but that is really impractical in most situations when you are sketching from the live model.

Basically think in terms of five values: a black, a white (usually the white of your paper), a value midway between them, and a value that falls midway between that middle value and each end of the scale.

This is a great illustration of a popular comment in art circles and elsewhere: K.I.S.S. That stands for "Keep It Simple, Stupid," and it keeps me out of trouble when I'm working. It will work for you, too. Whenever you are getting confused by having too many options—pencil or charcoal, newsprint or good paper, ten values or five values—simplify your work by giving yourself a K.I.S.S.

Judging Spaces

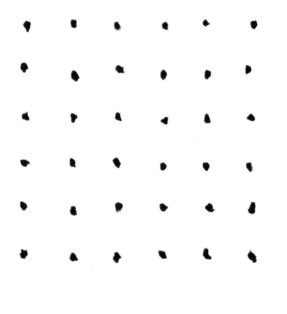

Here are some additional exercises to help develop your ability to judge comparative spaces, angles, and distances, as well as to tighten your control of your drawing instruments. Learn to look properly at your whole drawing as you are putting down each new line.

Put a dot anywhere on your paper. Put a second dot about half an inch away from it on an imaginary horizontal line. Now put your pencil point an equal distance from that second dot and stare at the two spaces. When you are sure that the two spaces are equal, put down your third dot. Continue to do this for four more dots on the same imaginary horizontal line.

Now do the same thing vertically, starting with the first dot, and continue until you have a grid of dots similar to the illustration on the left. If you are not very careful, the vertical dimension will be shorter than the horizontal dimension. As you work on the exercises on this page and the following pages, check your results by measuring. How did you do?

This next exercise will also help you improve your ability to judge and estimate spaces. Putting the new dot between two existing dots seems easier but also makes it more obvious when you have made a mistake!

This time, put down two dots about two or three inches apart. Put your pencil point exactly in the center between them. Just as with the previous exercise, you need to broaden your focus to include everything before you can accurately judge the center. Put down your third dot. Lift the pencil. How does it look?

Now let's try breaking the space between the two dots into thirds. You really have to strain to visualize the first new dot, but with a little practice, you will find that it can be done fairly easily. Remember to measure your results in the beginning; soon you will not need to check your work with a ruler.

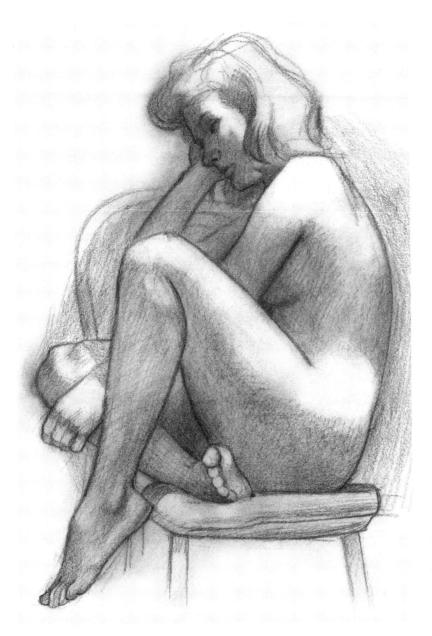

This drawing illustrates how the artist puts an understanding of relative spaces to use. Knowing how to make a dot half an inch away from another dot may seem like a strange skill, but it is a great way to teach yourself how to place elbows, knees, and other parts of the body just where you want them and where they need to be. Similarly, the angle exercises on page 16 will help you to judge angles compared to a vertical.

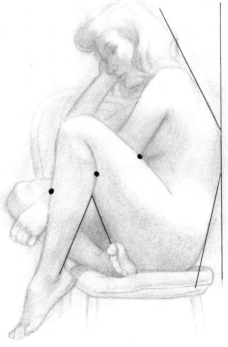

More on Judging Spaces

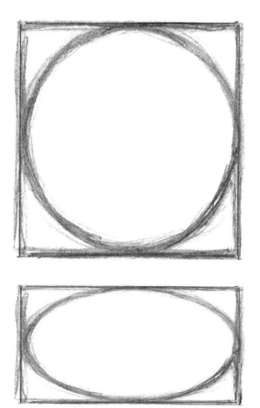

Here are two more exercises that will help you improve control and your understanding of relative spaces. Do these drawings freely and loosely; let your pencil flow around the circle before you bear down to make a mark. It may sound strange, but you need to "listen" to what your eyes are telling you.

Draw a perfect square, about two or three inches, by eye alone. You have the edges of the paper to help you orient it. Now draw a circle to fit it, using light, free strokes to get a feel for the square before you commit yourself to your circle. When your figure looks like this one, check it out by measuring it. As with the dot exercises, you will find that the vertical dimension is shorter if you are not very careful.

Now do the same thing with a rectangle, and fit an ellipse into it. Do this with several differently proportioned rectangles. Do circles, ellipses, squares, and triangles regularly; fill sheets with them. Learn to understand the relationship between a square angle and a curve.

In this next exercise, you will start learning to judge various angles against a right angle. In the drawing on the facing page, notice that the model's left arm is almost a perfect vertical. All the other parts of the body are positioned relative to that vertical.

Draw a right angle with arms approximately three inches long. Working loosely at first, then more firmly, as with the circle exercise, add a line to divide the right angle into two forty-five-degree angles. Check your work. How did you do?

Do the same thing again, but this time break the right angle into three equal angles. By now you have gotten the trick of staring at the whole drawing as you add another line or dot, and that is exactly what you should be doing.

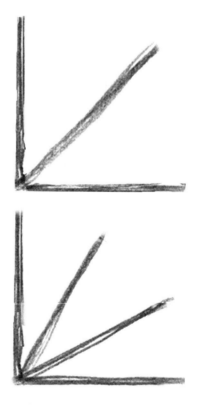

These little exercises will really develop your critical judgment faculties fast. They teach you to look broadly at your work, as well as to judge distances, spaces, and angles accurately. Change the sizes, change the distances, change the angles, invent a few exercises of your own, and keep your practice fun. Above all, COMPARE the thing you are drawing to the things that are already down by broadly looking at them both at the same time.

Getting the Most from Your Drawing Sessions

You have your materials; you've practiced your exercises until you can place an expressive line with pinpoint accuracy; your circles-within-squares would make a compass blush. What else do you need to go to your life drawing class? Mental preparation: Start thinking about what you would like to get from each session.

It is a very fortunate student who can get more than a few hours a week to draw from a live model. Good models are hard to find, and they can be expensive to hire on your own. It is important that you get the most benefit possible from these sessions.

Many life drawing classes will have the model pose in short poses—five or ten minutes—and in one longer pose. Get into the habit of returning to the sketches you make in class: redrawing or working from, and on, the class sketches. This will expand the benefits of these sessions many times over.

To return to your drawings, either draw right over a sketch or set it up squarely in front of you as if the sketch were the model, and work directly from it, extracting whatever information you need.

This will also tell you where your original drawing was wrong if things don't flow

together. You can take your obviously bad drawings and try to figure out what was wrong about them by trying to get them right. If you take a reasonably successful drawing and try to reduce it down to two or three smoothly integrated simplified shapes, your eye will improve dramatically.

Finally, drawing your models from memory, without looking at your earlier sketches, will help develop your memory tremendously. We all know that all drawing is memory drawing: You look at the model and then look at your paper to draw it. The interval is seconds, but it is memory nevertheless. When you redraw a pose later, the only difference is the interval.

You will find after studying a long pose of an hour or more, if you have concentrated on getting accurate information, that the details are burned into your memory. Try drawing that pose the next day without looking at your drawing of the previous night and then compare them.

Draw only what you remember; do not add anything. You are giving your memory and powers of observation a big boost when you know beforehand that you are going to redraw it later.

This forty-five-minute pencil drawing was finished later in my studio after the initial sketch from the model. It took an additional thirty minutes to carry it to this stage, giving me additional benefit from the original session.

This one-hour Conté crayon drawing was made from a five-minute sketch done in a session with the model.

The Model and Drawing the Figure

It is your first day in the figure drawing class. You are slightly apprehensive. Relax! Imagine how a first-time model feels—she is the focus for everyone in the room.

Your model is a professional and deserves your appreciation and respect. A good model can make or break a drawing session. When the model is enthusiastic, it shows in everyone's work. When he or she is really not interested, or is bored or sleepy, that, too, is evident in the drawings.

I think every artist should try modeling at least once to get an appreciation of how difficult it is to hold a pose for any length of time, as well as to understand how hard it is to regularly come up with good poses.

In most classes, the female models outnumber the males. This is evident in the proportion of females to males in this book. In my classes, we have been extremely fortunate to have had several exceptional female models. You will no doubt notice that despite my attempts to change their features, I have used the same models often in these pages. Each of them brings a special talent to the class, not the least of which is a genuine enthusiasm for posing. These models have a natural ability to take an unlimited variety of graceful poses. Never forget that the model is the most important person in the figure drawing class. Treat her that way.

The artist places special emphasis on the study of the figure for very good reasons. It is difficult for the average person to understand why we choose the nude human body over horses, dogs, or other readily available subjects. (One reason is pretty obvious: A human model will hold a pose for study, but try getting a horse to pose quietly!) Artists have always openly celebrated the mystery and beauty of the human body in all its shapes and sizes. They have recognized it for what it is, simply another of nature's awesome creations. We give it a special place among the others because, after all, it's us we're looking at. Naturally we are fascinated by ourselves. Naturally we would consider the human body among the world's most beautiful creations. We were programmed that way. Any other attitude would be an insult to its creator.

Why not draw the body with clothes on? We do that, too. In fact, it is a refreshing change to work with a draped model. But something is lost when the artist lacks an understanding of the rhythms and structure of the body beneath the clothes. The results are often as though the drawing was made from a mannequin with clothes on. If we were to complete the analogy to the horse, we would have to cover everything but the head with a blanket!

Recently I talked with a woman of my generation who was forbidden to go to art school because of the possibility that she would be forced to draw "naked bodies." This attitude carried over with her until she realized too late that she had a natural aptitude for drawing the figure. I wonder how many potentially great art careers have been nipped in the bud by the attitudes of people near to them. You simply need to have the strength to go your own way under those circumstances.

If these drawings, made in thirty minutes with a graphite stick and pencil, have a natural, relaxed feeling, credit goes to the model.

Working Without a Model

There will be plenty of opportunities to expand the experience that you get in your figure drawing class. Get in the habit of taking a small sketchpad everywhere you go—to the restaurant, shopping mall, airport, anywhere people gather. If you can find a place to work unobserved, you'll get plenty of fast action.

It takes a special kind of observation and sketching to get anything at the speed you need to work, and it won't be easy until you have some practice under your belt and you have learned to let yourself go. As you draw strangers rushing by, or people shopping, or bicyclists stopping at a light, or even other people-watchers, you will find that this is a good time to practice a caricature type of drawing, because at this speed, you can only get down the exaggerated essentials.

These drawings are from a tiny sketchbook that I usually have with me. Remember, there are models all around you. Don't limit yourself to one night a week; it is not enough.

But what if you cannot take a life drawing class at all? What if circumstances prevent you from getting out among real people? For you, the only possibility is to work from photographs, television (freeze-framing a videotape or DVD), or other sketches.

If you must learn to draw from two-dimensional materials, work wisely. Photographs are valuable sources of information, and many illustrators have used them. Work from good photographs or even magazines if they have reasonably simple lighting. Look for photographs

Back views are a challenge. Look for big shapes and put them down quickly. These drawings were made in my car. It makes a great studio.

that have a simple single light source. The biggest problem with commercial photographs is their fancy lighting, which forces you to slavishly copy every tone and conflicting value. As a result, you lose any sense of solidity in your drawings, and you tend to get involved too early with insignificant details because you know your model will stay put as long as you need him or her.

Combat these problems by putting the photo up in front of you. Treat it like a living model. As you will learn in the following chapters, do a lot of fast sketches, look for big important shapes, and get them down quickly. Don't fall into the trap of copying every little value or detail you see, and guard against the distortions you see in many photos. Do not put the photograph right next to your drawing while you work— don't compare the two directly until you check your work later. Remember, you get no benefit as an artist from copying a photograph. You are training yourself to see correctly.

There is no real substitute for drawing from a live model. If you are seriously interested in learning to draw, make every effort to go to a good art school with a life drawing class for at least a year. The ideas and exercises in the following chapters should help make that year an exciting and enriching one.

Most of these models were spotted in a shopping mall. Sometimes people seem to know when you are drawing them. Try to work unnoticed.

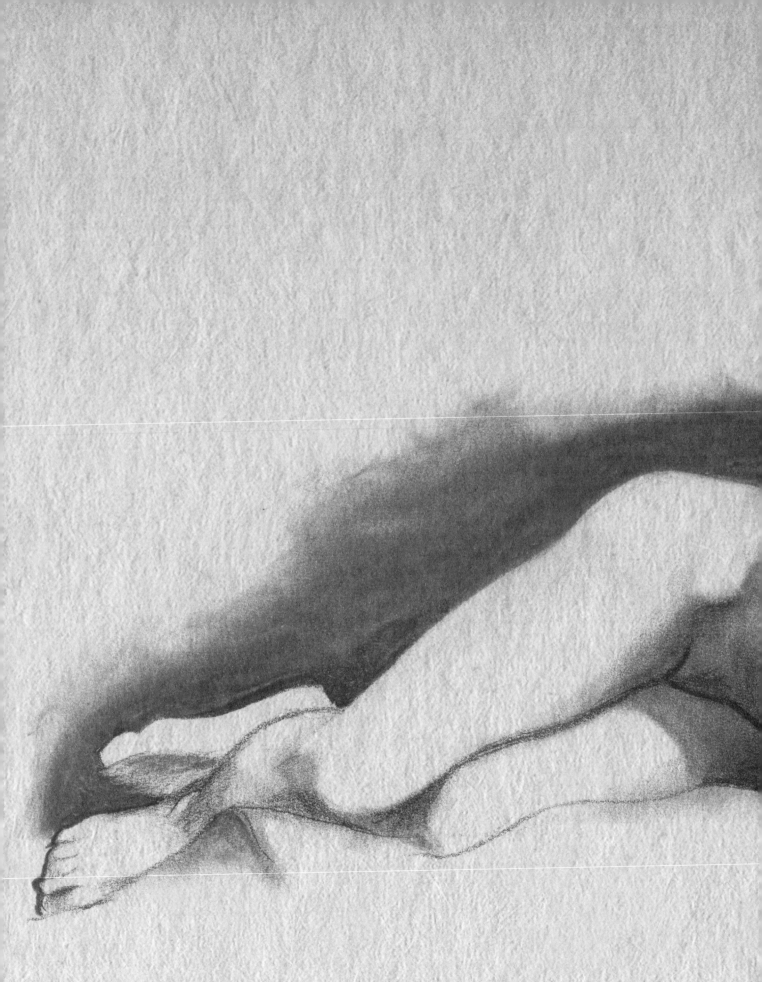

Learning to See Shapes

Relax as you work. Squint your eyes and study your model, semifocused, until the image simplifies into its most basic shapes and you begin to see the overall shape without the distracting details. Look for flat patterns and use those patterns and shapes to create your drawing.

Thinking About Shapes

There is a scientific theory, backed by research, that the two halves of your brain process information very differently. The left half approaches its job like a scientist: It is analytical and verbal. The right half of the brain is the artist: It considers things spatially and visually. I believe that the rational left half considers itself the last word in all things and tends to inject its logic even into creative areas.

This is a very simplified version of an important theory. (There are several good books on this fascinating subject, and I definitely recommend that you read one, because this theory helps explain several problems that artists come up against.) I believe that if you can put this knowledge to work, you will experience a dramatic improvement in your ability to draw.

Here is an example of the problems that this theory might explain: Every artist that I ever knew has had the problem of seeing his or her work in a completely new way several days or weeks after finishing it. It is extremely discouraging to finish a drawing you feel good about, only to look at it later and see blatant mistakes in proportion or basic drawing that should have been obvious while you were doing it. It seems impossible that you could have liked this drawing before. Sometimes, though not often, the opposite is true and you find that you like something you were prepared to throw out initially.

I believe that the "conflict of interest" between the left and right halves of your brain is responsible for this phenomenon. You focus too hard on the details of your drawing, summoning your logical left brain for its opinion, which it is only too willing to give, and the critical functions of your creative right brain are consequently turned off.

You can learn to minimize this problem by getting control of these two conflicting mental processes and making them complement each other as they were intended to do. You can learn to switch focus from one to the other at will.

Here is the trick. Stare semifocused at the object you are drawing. Gradually squint your eyes until you simplify what you are looking at. You will begin to see the overall shape without the distracting details. You will start to sense the flat patterns in the scene before you. This is an example of the right brain doing what it was meant to do. Do not concentrate too fiercely, as that seems to be an open invitation for the logical left brain to inject its opinion, and the last thing we want at this point is ice-cold logic. Try to put yourself into a relaxed, dreamy state. Practice looking in this relaxed way, and eventually it will come naturally to you.

If you consciously call up your new ability while drawing, you will notice a dramatic improvement in your work immediately. Do not expect a clear, obvious shift into seeing bold, flat patterns—your left brain will constantly try to intrude on your new vision and inject the more complicated three-dimensional view that logic tells you is there. The transformation can be dramatic for some people, but most of us have to be satisfied with something less. Nonetheless, for all of us, simple concentration on the flat-pattern aspect of your subject will still improve your drawing skill dramatically.

For another example of the human brain at work, look at the little circle at right. It is not a circle at all. It is simply two curved lines. Your brain perceives the arcs, the way they are positioned near each other, as a "circle" message, and you accept the image as a circle.

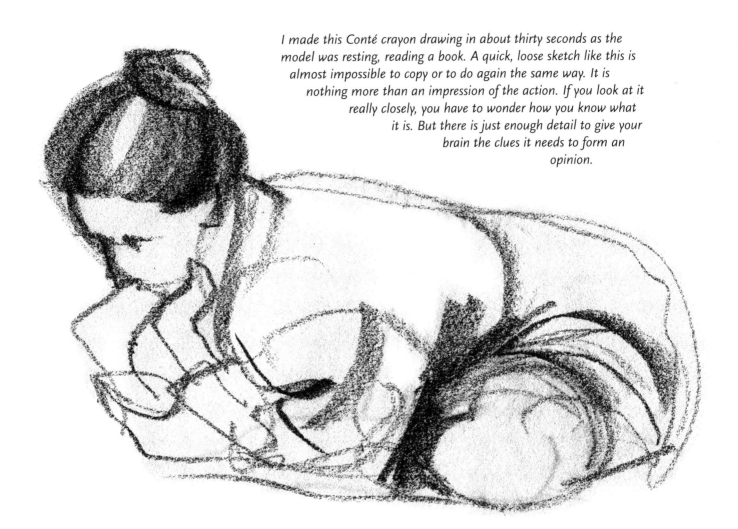

I made this Conté crayon drawing in about thirty seconds as the model was resting, reading a book. A quick, loose sketch like this is almost impossible to copy or to do again the same way. It is nothing more than an impression of the action. If you look at it really closely, you have to wonder how you know what it is. But there is just enough detail to give your brain the clues it needs to form an opinion.

Your brain does fascinating things with shapes and lines. Remember the pleasure you got as a child when you looked up at the shifting shapes of the clouds and saw all kinds of creatures in them?

The experienced artist takes advantage of this phenomenon in many ways. Understanding that people get great pleasure out of mentally finishing images that are incomplete or suggestive, he or she will put down just enough information to guide the viewer in the direction wanted, and then allow the viewer to participate in the creation by mentally adding his or her own finishing touches to the work.

All the viewer's brain needs is a slight nudge in the right direction, and it will eagerly jump in and interpret unfinished marks, smudges, lines, and especially shapes to an amazing degree. The human brain wants to do this. It enjoys it!

This is why simple shapes are so important when you draw. It is also why sketchy, unfinished work often has more impact than many finished pieces. When you carry a work past a certain point, you leave nothing for the viewer to do.

The Power of Shapes to Give Information

The amount of information that a simple outlined shape can convey is astonishing. These two images represent two stages in the development of a finished drawing—yet either one might be considered a finished drawing itself, because the viewer's mind supplies the missing details.

The simple outline on the left gives you its story in a powerful, direct way. Since it is uncluttered, it tells you clearly about the basic proportions and directions of the elements that are vital to getting a good drawing, without competition from less-important details.

The drawing on the right is much more developed. It tells you practically everything you need to know about this model and what she is doing. Adding the few details gives the viewer more information—although there is a small sacrifice of power and directness. When drawing the shape of anything, keep the sketch as simple as possible so your message comes off with maximum clarity.

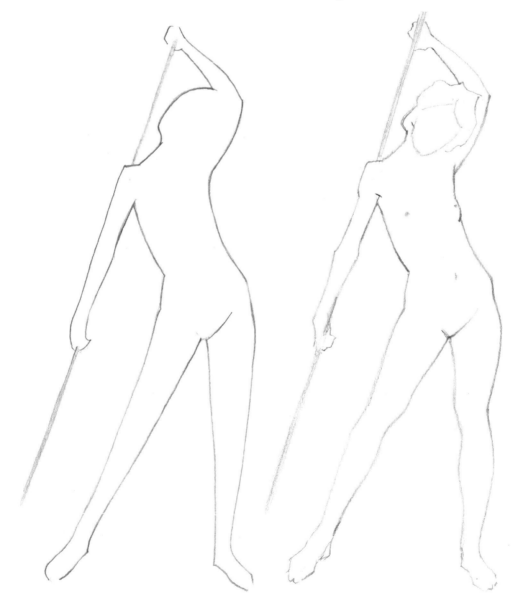

Look carefully at this simple sketch. It is a complete statement. It could stand alone as a finished statement, because your mind supplies the necessary details to tell you what it is, and if there were any serious flaws in the balance, proportions, or any of the basic shapes, your mind would quickly recognize them. Instead, while you recognize that the image is simply rough lines and flat tones, you enjoy the opportunity to participate in the creation of this piece by adding your own mental details.

This drawing looks deceptively simple. In fact, it could not have been done without a strong sense of the underlying structure of the figure. All of the major underlying muscle masses were unconsciously considered, and you can sense them at work in even the most bare-bones drawings.

This drawing was done by careful observation alone. It is accurate in all the essentials. It contains most of the information that the top drawing does—but it lacks the sense of life that is projected by the first drawing, a freedom that you, as an artist, gain through a thorough understanding of your subject.

This drawing also took much longer! I probably overdid the stiffness in order to emphasize my point, but I really found this drawing hard to do, and I could not generate any enthusiasm for it. And it shows. Of course, much better work can be done through pure observation, but the best work comes from a combination of knowledge of your subject combined with solid observation.

Everything Is a Shape

Squint your eyes slightly to soften your focus and eliminate most of the details as you look at any scene before you. All you see are shapes of differing values and colors. Some stand out starkly against their neighbors.

Squint to soften your focus, so that all you see are shapes. Some stand out starkly; others merge imperceptibly. There are no outlines—just shapes.

Others merge imperceptibly into background shapes of the same or close value. There are no outlines, just shapes.

If you were to put down paint of approximately the same values into greatly simplified shapes of the same pattern as you see, with no thought of the third dimension, concentrating solely on the pattern, then you would get a startling approximation of the scene before you.

You could do this with little knowledge of your subject. You would not need any magical artistic ability. The only thing you need is the ability to see and draw reasonably accurate shapes in the proper relation to one another.

As you learn to see shapes and to draw them with reasonable accuracy, you will eventually begin to distort and even manipulate those shapes to satisfy your own inner vision. That will be your artistic individuality breaking through.

Learning to see correctly in the shape mode will automatically solve problems with foreshortening. When you see things in flat patterns, you eliminate your internal struggle with your preconceived notions of what the thing should look like. You replace those notions with the sure knowledge of what they do look like.

This concept is difficult to explain to many artists who have trouble with foreshortening (and most artists do). They have been looking at things the other way—the wrong way—for so long that they find it hard to believe that the solution is so simple.

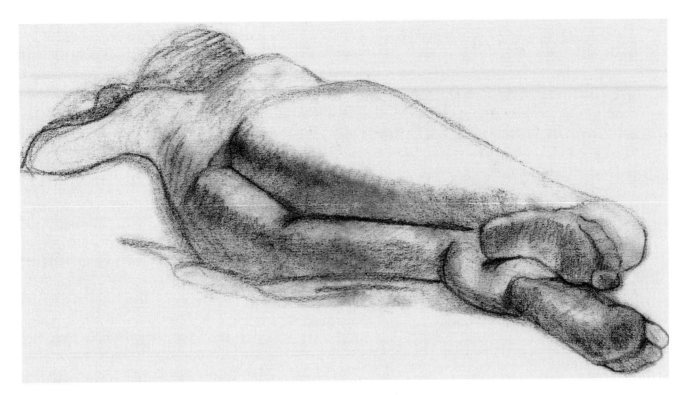

This sketch is a ten-minute study in Conté crayon. I had an awkward viewpoint, and while it doesn't make a good pose, it does demonstrate how seeing shapes does make it easy to draw even the most difficult poses.

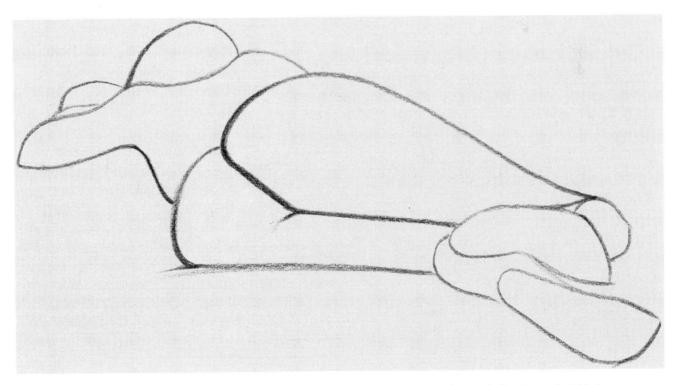

This drawing shows the simplified shapes that underlie the study. This is what the model looks like, flattened out into her simplest forms, and it also shows how an enclosing rectangle makes the figure easier to draw.

Drawing Curves

Y ou have already worked on exercises that help you identify and draw verticals, horizontals, and forty-five-degree angles. Now try this experiment to see why those skills are so important.

Draw this shape as accurately as you can. Copy it as closely as possible, making your drawing the same size as the original. Work on a sheet of tracing paper so you can check your drawing later by putting it right over the book for comparison.

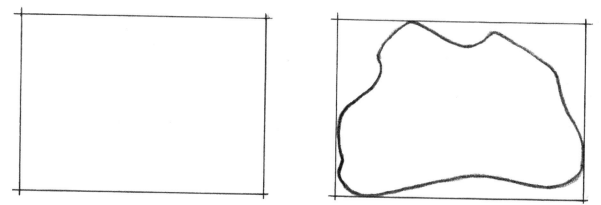

Now try it again. But first draw a properly proportioned rectangle, then draw your shape inside it.

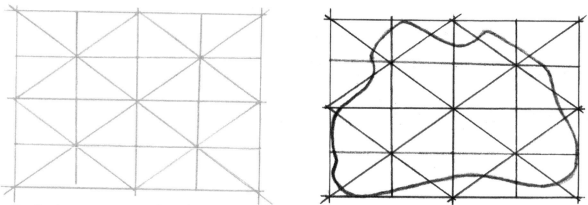

Finally, draw a new rectangle and create a grid like the one on the left inside the rectangle. Now, using my drawing at the right to guide you, draw the shape inside your grid.

What did you learn from this experiment? You should have learned that it is difficult to draw an organic shape simply by looking at it. Drawing shapes like this gets easier and easier as you add reference points.

Of course, the model is not enclosed in a box or a grid. Nor is the model printed on a page so you can draw right next to it for comparison. The human body is also a much more complicated shape, so our job is considerably harder.

The curved lines that surround organic shapes are not the smoothly rounded things that you could get with a compass, and you need to observe them very carefully to preserve their character. So let's consider how you can see and draw these curved lines more accurately.

The secret lies in reducing the curves to straight lines so you can see their directions more clearly. After you get the basic flattened shape down lightly, you can smooth it out later if you wish. But often the shape has better character when left in its slightly flattened state.

Now you should be able to see that if you can recognize a vertical, horizontal, or forty-five-degree angle, you will have little trouble judging how the lines deviate from these directions, and you will draw them more accurately. First you simplify the big directions, and then you fine-tune them.

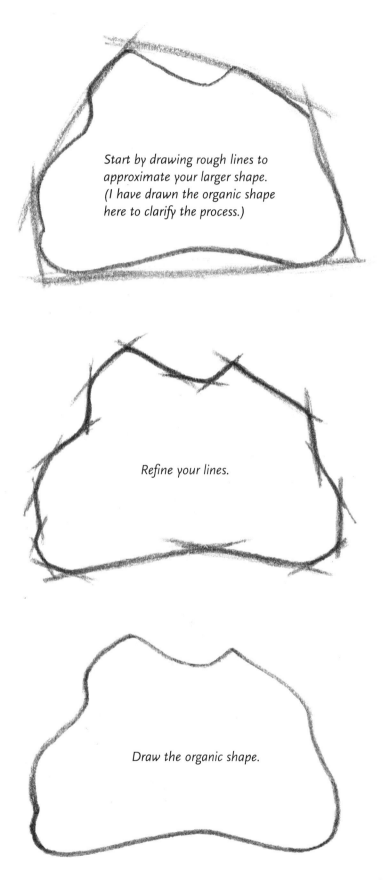

Start by drawing rough lines to approximate your larger shape. (I have drawn the organic shape here to clarify the process.)

Refine your lines.

Draw the organic shape.

Good Shapes, Good Drawing

All drawing is shapes—simple, rhythmic, flowing shapes that are all related to one another and unified into one beautiful, simplified whole like the single notes that blend into a symphony. That's all there is to it. When you really understand these words, you will be well on your way to a dramatic improvement in your drawing skills.

The problem is that you—or that part of you that thinks it knows what things should look like—block yourself from seeing things as they really are. Our brains tell us that the things we see are solid and three-dimensional, and we insist on trying to capture this solidity long before the drawing is ready to be developed in that direction.

As a result, we concentrate on the secondary details before the simple basic structure is established, with all of the accompanying distortions and inaccuracies that are the result of looking too closely, too early in a drawing. Once you begin to tighten down on the small details, you can no longer see the overall big shapes. You don't even know when your drawing is bad until later, when you look at it with a fresh eye, and then you wonder how you could have missed all those mistakes earlier. (That's your right brain taking a look at something your left brain took responsibility for!)

Learn to disconnect the left side of your brain. Remember, the best way to see the overall shape of a thing is to squint your eyes down until all the little details merge into place. When you see the whole shape simply, you can see the basic problems easily. There are no competing details to complicate things yet, so the important things jump out at you. If

your first, most basic drawing is correct at this stage, you can detail it as much or as little as your skill and interest allow.

Shapes are all you can see in nature, whether it is the shape of an object or the shape of any of its parts. It follows, then, that the big, simple shape of a thing is its most important visual aspect, and all of the smaller shapes it contains should be subordinate to it.

There are great opportunities for creative distortion and simplification in the drawing of these shapes. That is where your own personal vision will show through—but first you have to be able to see the shapes and draw them reasonably accurately before you can tamper with them.

Once you develop the ability to see and draw these big shapes accurately, you can manipulate them or break them up as much or as little as you want, but all the smaller shapes and details are only a part of the bigger overall shapes and should never compete with them for attention. In general, the simpler a drawing is, the better it is.

Anyone who is willing to work and practice can learn how to draw accurate shapes. But ultimately it is what you do with those shapes that will set you apart from the crowd. It is here that you succeed or fail in your efforts to communicate with your art.

Shapes play the dominant role in all art, whether you are working in the more creative and design-oriented styles or the strictly representational or realistic approaches shown on the facing page.

Here we see the role that they play in realistic thinking as you draw.

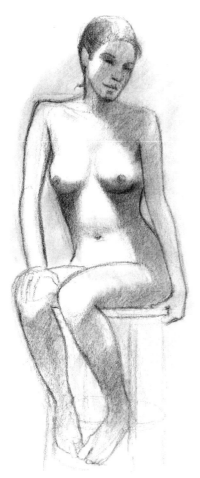
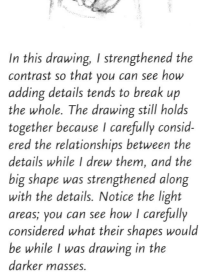

In this drawing, taken almost directly from the original in my sketchbook, you can see that, while the big main shape of the figure is broken up into smaller parts, it still dominates and controls all of its parts. You see the drawing as a simple figure, not as a mass of small details.

In this drawing, I strengthened the contrast so that you can see how adding details tends to break up the whole. The drawing still holds together because I carefully considered the relationships between the details while I drew them, and the big shape was strengthened along with the details. Notice the light areas; you can see how I carefully considered what their shapes would be while I was drawing in the darker masses.

Here the details began to mass together in strong, but simpler, shapes of their own. Because the smaller shapes were properly integrated into the larger one, they still belong to the whole and the identity of the subject is not lost. But this drawing is very different from the original sketch. Massing the details begins to offer opportunities for a more abstract, design-oriented approach.

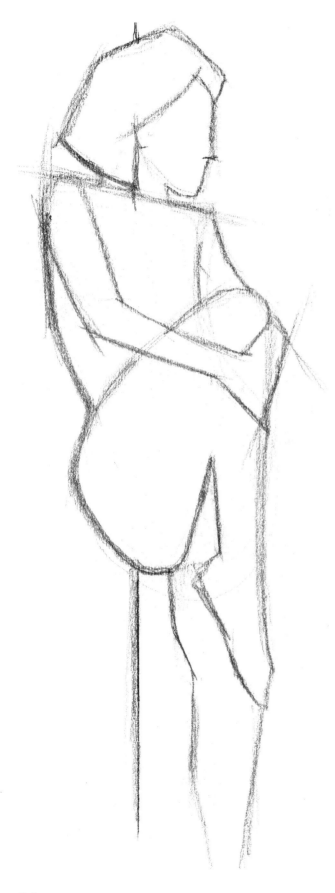

Plotting the Basic Shapes

How do you put together the shapes and lines to create a figure drawing? Here are some examples that should make the process clearer. On this page, the drawing illustrates the value of straightening curves slightly. Notice that when the lines are straighter, it is easier to judge their directions. The vertical line is the edge of a pillar that the model was leaning against, and it served as a reference point from which to determine all the other angles.

The top drawing, opposite, shows how much easier it is to position the shapes in correct relation to one another when you start with the big shapes. When you look at the model in terms of shapes, you see that her lower body becomes one big triangle, and her foot fits into that major triangular hip-and-thigh shape. The size and placement of the upper torso mass was easily determined by comparing it to the existing simple, triangular shape. The head and the hand were placed the same way. Very little guesswork was needed. Once you have placed the largest pieces of the puzzle, everything practically positions itself. Simply relate everything you add to the information you have already put down.

I began this bottom drawing, opposite, by positioning the baseline of the pose. The second line was the roughly parallel line above it. The full line was swept in, and so I had described almost the whole pose in the first two lines. The beauty lies in the big simple shape, and very little extra information is needed beyond that. It also told me that the torso was slightly too long, but that would be easy to fix at this point. Except for that problem, these drawings are accurate in the basic essentials, because I started out properly. It would be easy to go on adding details until you reach any degree of finish.

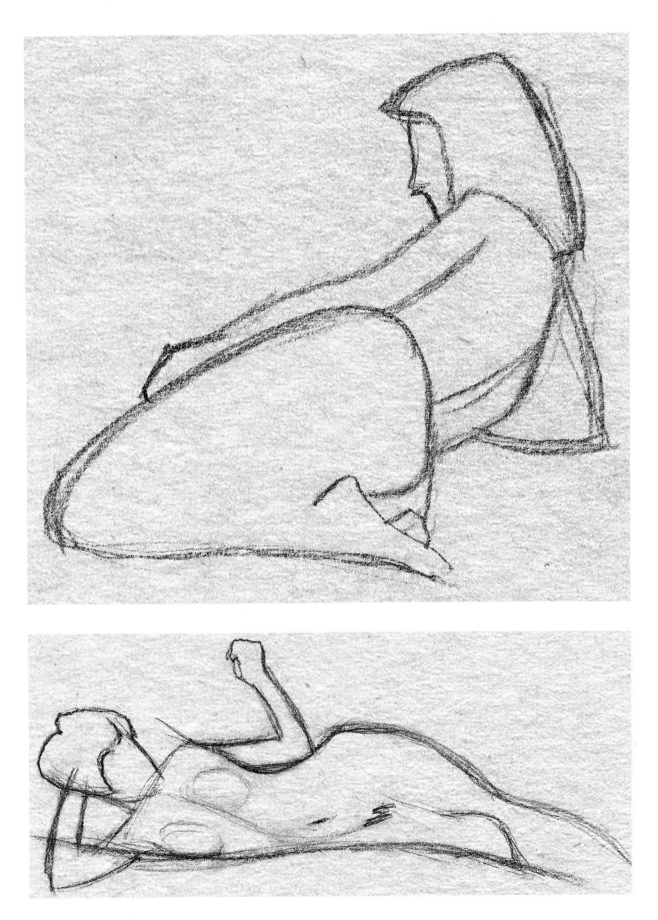

The Planar Structure

Look at the planes on the human figure. The rounded forms that make up a body can be flattened, just as you straighten lines to draw curves more accurately—only now we are considering the whole surface, not just the outer contours. The ability to visualize this planar structure of the figure is a necessity if you want your work to develop the feeling of solidity.

Students are often told that they can break up the figure arbitrarily into planes, but the results you see in class prove that this is not entirely true. Each of us might see the planes differently, and each body has its own structure, but there is not much room for interpretation without losing the real structure of that particular body.

There is a definite place on every curved surface (except perfect geometric figures such as a sphere) where the surface curves more abruptly than the major curve. You need to develop a sensitivity to the imaginary lines that result from the turn of a form at these places. Sometimes the lines are very apparent, and at other times they are not.

Start by getting a sense of the big simple planes of the front, side, and back. Try to determine where the form shifts from being contained in the frontal plane to the side plane, and so on. In other words, square it off.

To do this, take one of your simpler outlined drawings. Use a light drawing made in class and draw right over it. Try to run your pencil along the line that separates the front from the side, and put in a simple flat tone as I have done in the drawing below. (The drawings on these two pages started out as pages from my sketchbook, and then I did the same things that I am telling you to do. Remember, these are exercises to help you see more structurally—you do not want to draw this way normally!) The drawing on the facing page is an attempt to carry flattening of the curves to the next level. The fact that there is no model in front of me for clear observation results in a pretty stylized and mechanical study, but the exercise still has great value.

Try it without the model, as I did here, and also try it with the model in front of you. You will quickly see the difference in the results. If you work with both of these approaches for a while, you will soon see solidity and a better understanding of the form. You will find that, in many situations, a carefully placed line where the form changes from the front to the side plane is all you need to get the structure more solid.

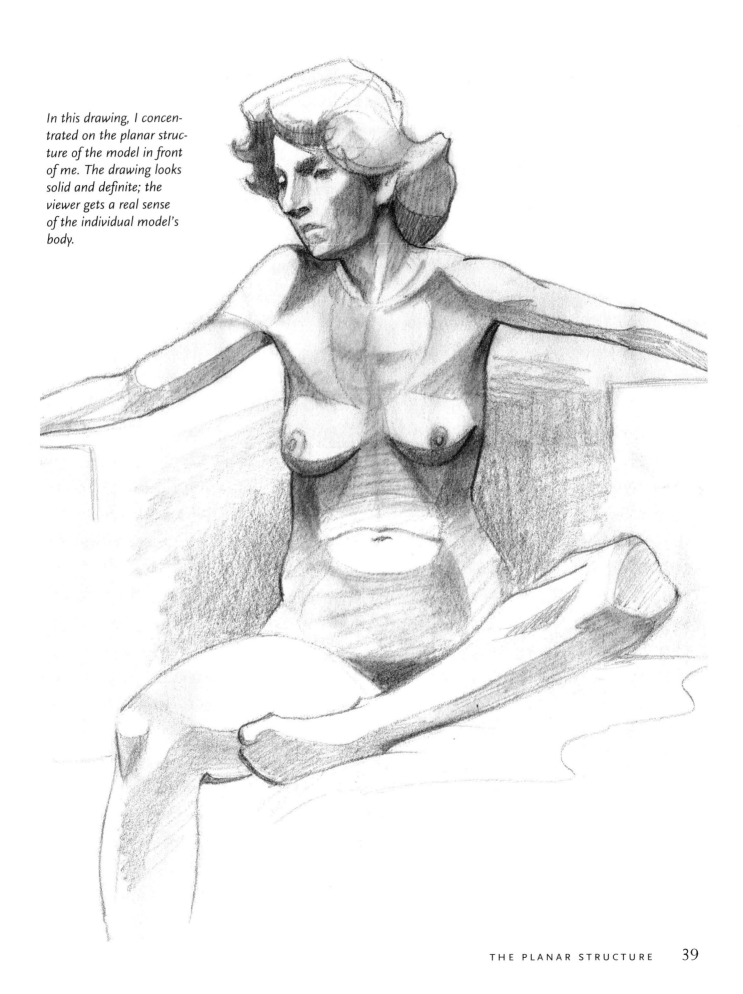

In this drawing, I concentrated on the planar structure of the model in front of me. The drawing looks solid and definite; the viewer gets a real sense of the individual model's body.

Studying Shapes Without a Model

You can use your old sketches from classes for many kinds of studies. A great way to develop your sense of big shapes is to draw right over your drawings, trying to strengthen and simplify the shapes you can see in them. Reduce each pose down to as few simple shapes as possible.

This drawing is a page from my sketchbook, worked over this way. After doing the extra work on it, I can now see that the leg mass is slightly too big. I missed that before it was simplified.

If you prefer to save your originals, you can work from your drawings on a separate sheet. Pin up your original sketch and use it as the model; that is how I made the drawing on this page. Use drawings by other artists in the same way, to study them.

Working on your drawings in this way gives you a different slant from when you study shapes with an actual model. You will always get better information directly from the model, and you should always be looking for these big shapes as you draw when the model is present. But the techniques here will help train you to look at the model and get the information you need.

On the Surface

When you lay in the figure, you need to see it in the flat pattern mode. But when you want to finish it in a realistic fashion, you must develop an acute sensitivity to the third dimension. Let's take a look at the surface, and how to enhance the feeling of solidity of your shapes.

The most obvious method is rendering objects in tone, either in light and shadow or with sculptured modeling. But there are things that happen on the surface of a figure that can be portrayed in pure line, and if you get them wrong, you destroy your chances to get solidity even if you render the tones beautifully.

Little touches that force the viewer to see the object as three dimensional, even when you don't actually see them on the model, can be added to your drawing. But first develop your own sense of the surface of things. I have used inanimate objects here for clarity, but the principles are equally true for the figure.

Obviously the model doesn't usually have lines or patterns over the body. A model does have subtle marks or changes in skin tone that add to the feeling of solidity. Even brushstrokes or the way you stroke your pencil or other drawing tool can enhance, or destroy, the solidity.

Draw the following examples to test your sense of surface. Do them loosely and freely; you can only go by "feel." Don't worry if you find the concept difficult; this skill can easily be developed and improved.

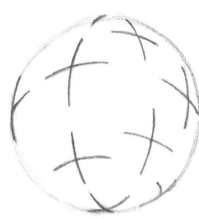

First draw a circle as accurately as you can. Now picture your circle as a solid ball. Try to draw crossed lines on the surface. Imagine that these lines cross one another at right angles.

This view will show you that your choice of angle can destroy the sense of solidity. The center placement of the first cross forces you to draw the arms of the cross in a straight line, and that destroys the sense of roundness—even though the drawing is accurate.

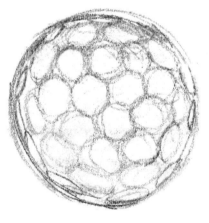

Try drawing another circle. This time, draw little circles, all the same size and touching, over the whole surface of the ball. Notice that the little circles are practically undistorted over most of the surface, and only begin to show as ellipses in the outer one-sixth of the ball. The distortion only occurs near the outer edges. If you distort too soon, your ball will look wrong.

The same principle: This time we work with straighter lines on a columnar surface. Until you get to the outer one-sixth, there is no significant change in the spacing of the lines. These could be bark ridges on a tree trunk or any column that has roughly evenly spaced vertical lines on it.

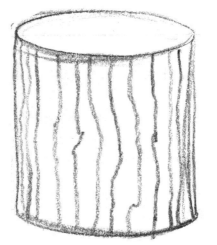

Random lines on a ball. Note that all the lines in this figure flatten out and follow the perimeter of the ball. You can sense the third dimension in this figure.

The same technique gives dimension to a free-form shape.

Note how a tiny overlap of the edges of this shape changes the angle you perceive it to be from you.

A slight smudge with the tip of your finger can force the illusion of solidity. In this case, it could be a bent knee. Look for this trick in many of my simpler drawings throughout this book. It is a powerful way to force the feeling of solidity when you have bad light on the model.

Using Smudges and Shapes

I hope that you understand the importance of working in shape mode now. This is the key to good figure drawing.

We have only touched on shape as it relates to the realistic mode of drawing, but shape is also the big player in all other styles of art. The ability to draw, manipulate, and organize shapes is actually the whole history of art.

In this ten-minute Conté crayon drawing, the finger smudge has been used on the front knee and behind each calf. One simple stroke around the surface really helps the sense of the solidity of the leg.

The lighting was badly broken up, so I resorted to this approach.

The strong black line on the figure's back was put in by pulling it down to a quickly placed dot. The drawing measures about eighteen by twenty-four inches.

Can you tell where the smudge was used here? The same flat, form-destroying light was on the model and made this approach necessary. This is also a ten-minute Conté crayon drawing, eighteen by twenty-four inches.

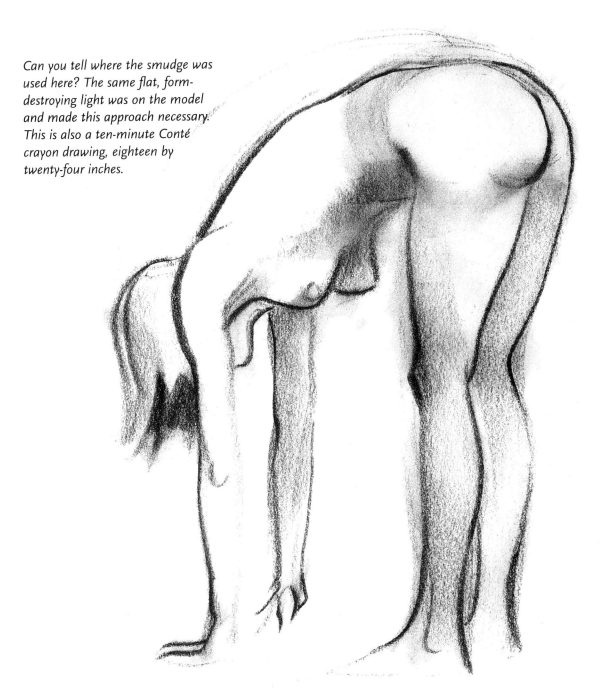

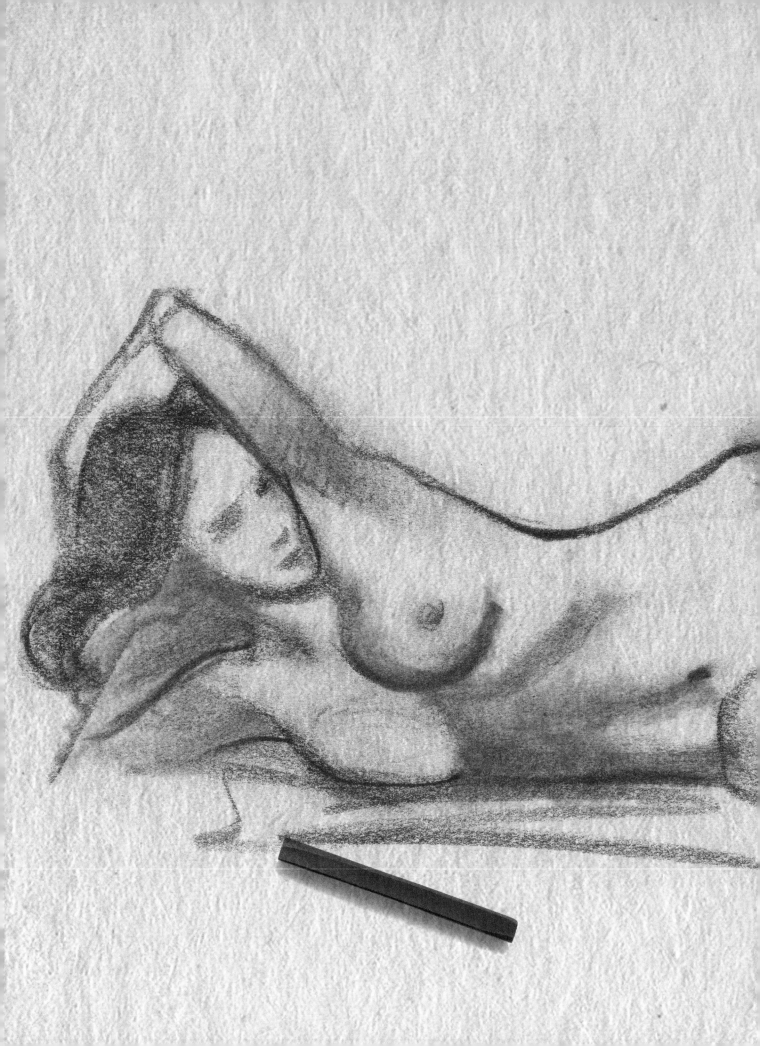

Beginning to Draw

You are ready for the life drawing classroom.
Does the blank sheet of paper seem intimidating?
In this chapter, we will look at different ways to start
working, techniques to capture the model's pose,
and a wide variety of approaches to keep your
drawings fresh and fulfilling. A figure
modeling class is the first step on the
journey to becoming an artist.

Good Start, Good Finish

A good start usually means a good finish, and a bad start a disaster. Whether you are going into your first life drawing class or you are an accomplished artist, this remains true. Fortunately, a drawing can be forgiving of mistakes in judgment in the beginning if the marks are made light enough. Except for those times when you are working on lightning-speed poses of one minute or less, there really is no reason not to get the first few shapes down accurately.

The trick is to find the thing that is easy to get right and build off it, going slowly and deliberately enough to be dead certain that you know that the first few things are correct. In a reasonably short time, the drawing gets easier and almost begins to draw itself. It is only when you are careless in the first few lines or shapes that errors start multiplying, and soon you may as well start over.

Of course this is easier said than done. It takes some experience to know what to look for, but you will learn quickly and you will enjoy the challenge. What are the things you look for? Everyone will see things differently, and you ultimately have to find your own way; but I can show you what I myself look for, and let you go on from there.

Starting can be broken down into two basic, broadly defined approaches. The first is mechanical: You carefully measure everything before you put it down. The second is purely intuitive: You simply jump in and throw lines in as you feel them, in the hope that something will come of it.

The first method can be tedious and boring, and often results in boring, academic drawings. The second method is much more stimulating, and very popular with today's artists. Unfortunately, in untrained hands, it almost always results in meaningless, trivial, shallow drawings. So where do we go from here? The answer is clear. You cannot handle the second approach without going through a period of trying the first. When you get what you need from the first, you will find your own style in a combination of the two basic approaches.

There are artists who start by drawing something as small as an eye, finish it, and move on from there, carefully relating every new addition to the stuff that is already down, with surprising results. I know of a painter, one of the finest of our generation, who claims to work painstakingly in pieces like that, and his results are fabulous.

But I think drawing has a special kind of language of its own that is lost in a too-meticulous working process. Drawing can be just as expressive as painting, and to my eyes something is lost if the image is not captured quickly and with feeling. The searching line and the scribbled tone add something rich and indefinable to the expressiveness of a drawing. They are a vital part of the language of drawing and show the artist at work.

There is no "right" way to start every time. If you avoid falling into habits—such as always beginning with the head—and approach things logically, by looking for the easiest thing to get right, then the next easiest thing, and so on until the drawing seems to lead you on, you will find drawing much easier and more rewarding.

Before we begin, let's get rid of one major block to getting a good start. That block is the unreasonable fear of a beautiful untouched sheet of paper.

Take a good look at this rough five-minute sketch. It is full of scribbles and searching lines (some so faint you cannot see them), along with a good amount of dirt. All those early lines and messy marks were left in, because they add to the ultimate effect. They do not detract from it. It is not my best work, but it still captures a mood, a feeling, an expression.

So, loosen up, dive right in, and do your best. So what if it fails? It's only a piece of paper with some marks on it.

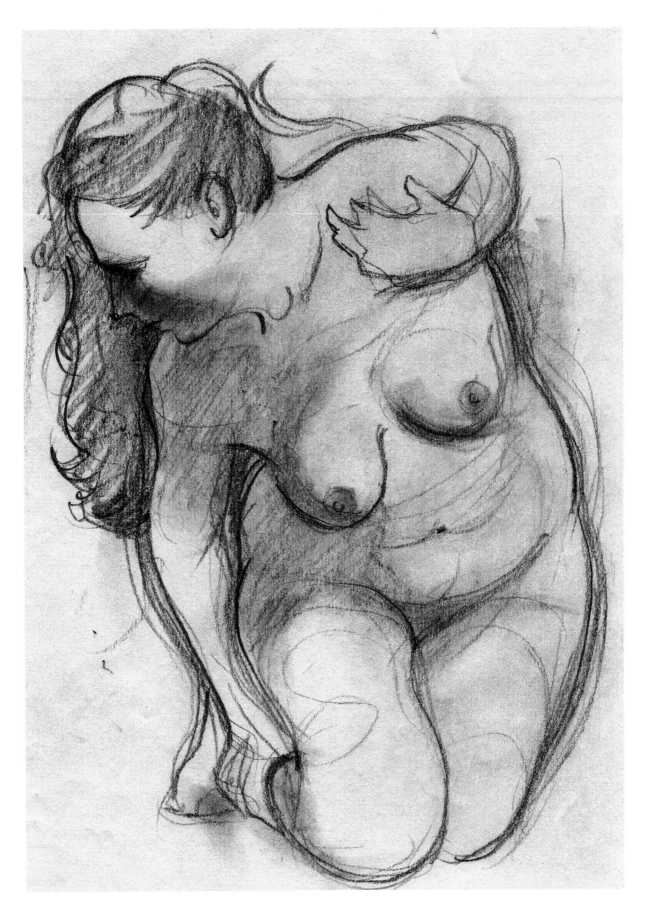

Super-Quick Starts

A good way to explain how I start a drawing is to show you some examples of super-quick sketches. Working on these fast poses, held for just a few minutes, it is necessary to get only the most vital information down in the shortest possible amount of time.

This is the way I start most of my drawings. Everything of vital importance is considered in

these sketches, including the vertical alignment of every line as well as the exact positioning of the hands and feet. The proportions are done by instinct, but if there is anything really wrong with them, it can easily be seen at this point. Never continue beyond this stage without correcting noticeable mistakes in proportion or orientation, because you will simply be compounding your errors. This is a good time to do your measuring if you feel the need to.

Drawings like these, made with graphite stick in under one minute each, are much harder than they look. You need to make lightning decisions on the importance of the various factors to get them the way you want them. There is no time for conscious thought, so this is where your earlier training and study pay off. The more you practice, the more subconscious and instinctive your work will become.

All four of these sketches could be developed to any desired degree of finish with very little modification of any of the important factors. They are starting points for further work.

Same Start, Different Finish

The drawings on both of these pages were started in the same way but then carried forward differently. Both were started with the flat side of a Conté crayon, broadly stroking in long, light, sweeping lines. But the drawing on this page has been developed using line to place emphasis on contour. The drawing on the facing page has been finished with extra emphasis on tone.

In the drawing of the male figure, the line between the two versions shows the relation of the figure to the vertical. I always consider the relationship of the figure to the vertical and horizontal axes before placing the first line. Feet and hands are placed very early in the process.

Notice the arms. They were roughed in as simple flat tones, showing the direction of the whole mass of the arm. The hands were just strokes of this flat tone, no details.

The legs were straight lines to show their direction, and to orient and anchor them properly to the ground.

The sketch on this page is being developed by a line approach.

It is during the development that the slight bend of the knee and other subtleties are noted.

The sketch below was developed sculpturally in tone, using the side of the crayon, and I was more concerned with the simple masses and bulk. Note again the placement of the feet and hands, and also the left side of the body and the surface of the box the model is leaning on. These were some of the first marks I made on the paper, and they are not arbitrary.

From this stage, both of these poses could be carried to any desired degree of finish very easily and in a short time.

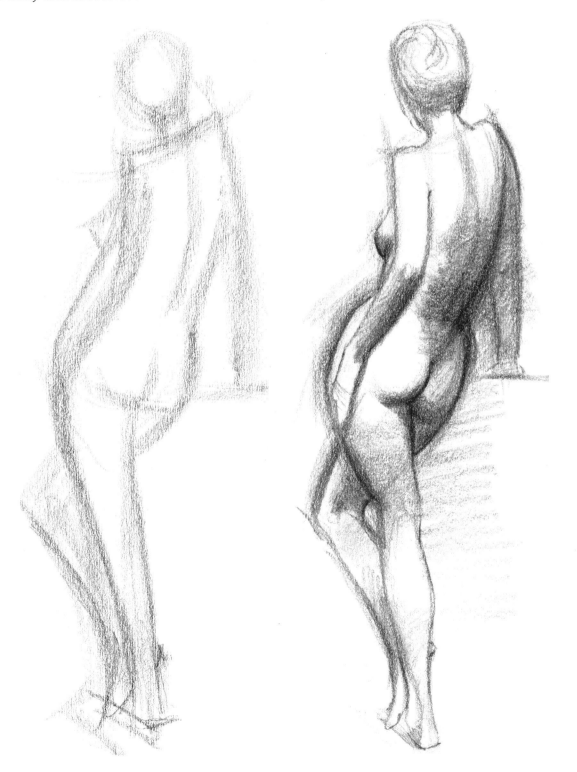

Two Lines and an Arrow

The more information you can put down accurately, and the "bigger" that information is, the easier it is to relate the rest of your work to it.

This has led me to an approach that I can count on when I get one of those poses that are particularly hard to unlock. It has also served well in the early stages of an illustration, when I needed to work out a piece without a model. You can rely on it, too.

The basis is simple: *The whole human torso can be accurately and easily placed with two lines and an arrow.* The torso is more than half the mass of the body—it's big. If you get the torso in

right, the rest of the body gets much easier.

The two lines establish the right and left boundaries of the body, and they must be properly oriented in relation to the vertical.

The shaft of the arrow is the midline of the torso and needs to be carefully drawn to show the twist of the torso (if any), as well as the angle of the torso in relation to your view. The arrowhead represents the crotch—which, conveniently, is the midpoint of most standing figures.

Try this idea for a while. You will find it works on most poses and really is a powerful tool to help you visualize and understand the figure.

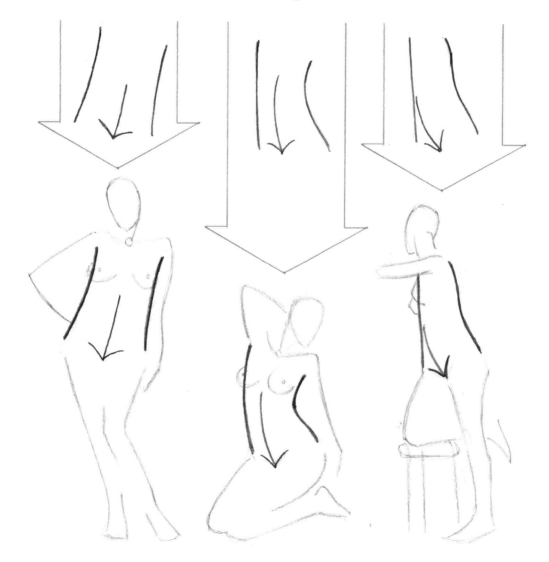

The two-lines-and-an-arrow
approach works well for more than just
standing poses. I used it on this sketch of a
reclining figure by drawing a careful contour
line along the top edge of the torso to start, then
lightly adding an imagined baseline and an arrow.
Even though the positions of the baseline and
the arrow were hidden from view on the model, the two
lines and the arrow gave me a solid unit to work off, and I
drew the leg right over. The long, extended leg and the hip
were easy to visualize after these first three lines were in.

This two-minute drawing of a stretching woman was
done with two full-length lines on both sides of the figure.
You can visualize the arrow; I had put it in very lightly.

After you get some experience, you will be able to put in
these long lines on many poses in an almost finished way.
You need to relate one to the other carefully. Yet even if they
are slightly off, they can add a special character to the draw-
ing, and sometimes it is better to leave them alone rather
than overwork them.

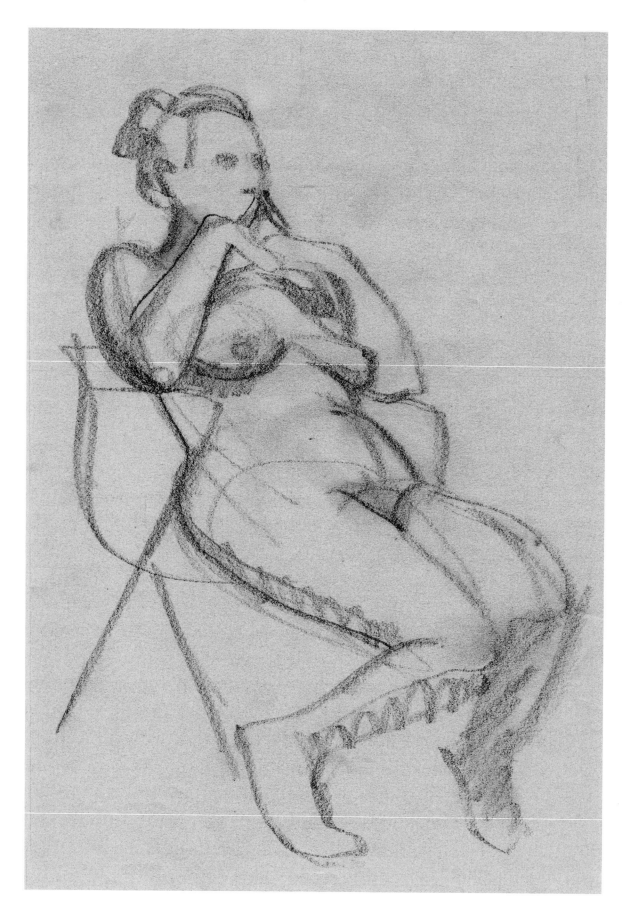

Starting with One Big Simple Shape

Now you are ready for some "tricks of the trade" of figure drawing. These points are not generally known among those who try to draw the figure—and the consequences can be fatal to a drawing.

The first "trick" has to do with positioning the feet. If this position is wrong, it can completely destroy the sense of solidity and space in your drawing. Positioning the feet incorrectly is a very common mistake, and it is easy to avoid. Here's the secret: When a model has both feet on the floor, in any pose, standing, kneeling, sitting, or even lying down, the foot farthest away from you is always higher up on your paper.

This basic tip on perspective seems so obvious that it is amazing how often it is ignored. It is so crucial that I will often place the feet before I put in the legs to connect them to the body, as I did in the small sketch here.

The next "trick" is that whenever you need to place anything else that is critical—in this case, the hands, but it could be an elbow leaning on a pedestal, a foot resting on a knee, or practically anything that needs to be placed precisely—put the critical element in first, as soon as you know where it has to fit. These elements don't need to be detailed, just roughly indicated. The placement cannot help but be right if you do them this way.

How are these tricks used in the drawing process? Here is a step-by-step example. For the drawings shown here, I started with one big shape. Sometimes, when you are working with shapes, it is possible to see a simple, big shape. Usually it is the torso. In this case, the torso reminded me of a giant kidney bean. So I drew that in first. Be careful to orient it right. You can see it clearly in my little sketch. When an area as big and important as that is drawn correctly, it becomes easy to see how the rest of the figure should work.

Next I located the knees and drew them in, then the hip and thigh shape.

Now, using my first "trick," I was ready to place the feet, even before the lower legs. Next—another trick!—I positioned the hands, because they had to be in exactly the right position; then the elbows. The rest was easy.

Note that the first shape was too long, but if you relate everything as you go along, you can catch that and remedy it with no problem. Working in this way, you tend to see the solidity of the object, so you need to be careful to think in terms of flat shapes, to visualize the relationships as though they were on a two-dimensional plane.

By the way, have you noticed that when you draw using these methods, you are forced to look at your drawing and visualize it before you draw it? How else could you place the feet before you drew in the legs? This is just the way you should be working—visualize first, draw second.

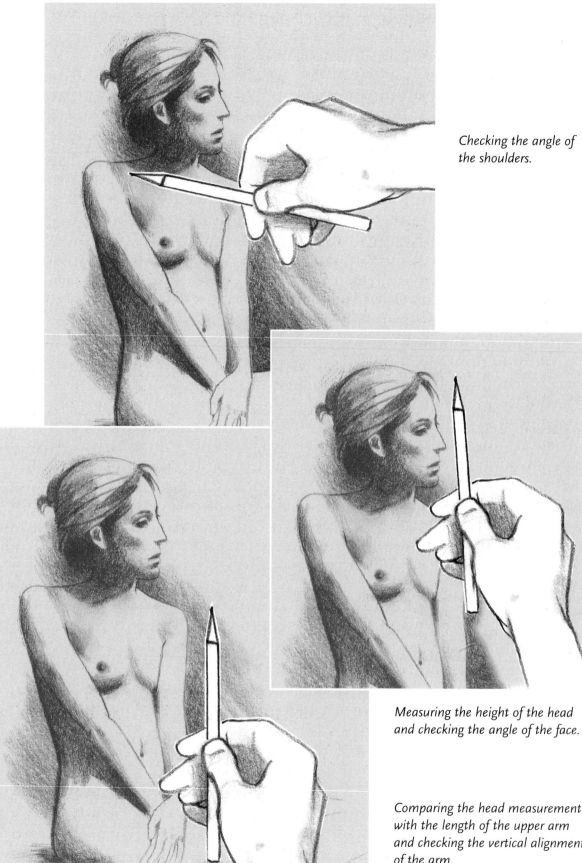

Checking the angle of the shoulders.

Measuring the height of the head and checking the angle of the face.

Comparing the head measurement with the length of the upper arm and checking the vertical alignment of the arm.

Measuring and Accuracy

When you first start to draw the figure, you need to measure, looking for the exact angles, comparative sizes, proportions, and line directions of your subject. To measure at first, hold your pencil out in front of you at arm's length. Using your finger or thumb as a place marker, compare the various sizes and directions of the model's body before you draw.

I recommend that you measure in this way until you have learned to compare the various lengths and sizes on your model. Then drop the mechanical method and force yourself to do the same thing by eye alone. Once this habit is developed, you should be able to do it accurately enough to stop using your pencil as a crutch.

The idea is to develop the ability to do all the comparisons automatically and quickly so that you will be able to work much faster and more freely in the early stages of your drawing. Just don't get sloppy with your calculations—they still need to be right. The essentials leave little room for interpretation. Even after you stop using your pencil to help you measure, you should measure things after you draw them for a while. You will know when you are ready to move beyond that, but it is a reasonable idea to check things periodically anyway.

Here are some of the things to check for: the center point of the figure; the size of the head in relation to any other part of the body; the size of any part you are not sure of; the vertical relationship of the feet to the rest of the body; the general alignment of different body parts to one another; the vertical alignment of the whole pose; and any horizontal lines or shapes. Remember, you are not really measuring things; you are comparing them to something else.

What do I mean when I use the word *accuracy*? This word has a tendency to turn off most artists when they see it. It seems to preclude creative expression, and that, of course, is pure poison to anyone with sensitive creative leanings. But when I talk about accuracy, I mean two separate and distinct concepts, depending on your stage of development. Put simply, when I say accurate, I mean accurate in all of the essentials—the essentials being anything that can affect the whole aspect of the drawing. The essentials are: the relationship of a line or shape to the vertical orientation (the horizontal direction is also important, but much less reliable because the perspective throws this direction off except at eye level, or unless you are looking at a horizontal surface straight on); the relationship of sizes between parts in your drawing; the positioning of the feet or other parts of the figure that rest on a flat surface; the placement of the hands; the tilt of the head; the angle of departure of a line or shape from the vertical; the relationship of values (lightness or darkness) to one another.

Any of these essentials can be changed consciously by an experienced artist to get a particular expressive quality in a drawing. But these changes should be made only after you have developed the habit of accurate observation and are no longer satisfied with the results that absolute accuracy gives you. At this point you are still training your eye to look for these essentials automatically. You get no benefit from sloppy thinking during this stage of your development.

The larger meaning of accurate, as I use it for the advanced student, is getting the big, main shapes, lines, or values and their relationships to one another the way you want them. All the smaller details will logically follow.

Start by measuring, using your pencil as your ruler. Gradually move away from that beginner's technique as you grow as an artist. In time, you will find that your accuracy, and your perception of accuracy, grow and develop in new artistic directions.

What's Wrong with This Picture?

In these drawings, it is easy to see how you can take liberties with accuracy and with shapes if you know what you are doing—and how you can get into trouble when you deviate from the basics without knowing what you are doing.

The big drawing was made by starting with a light kidney bean shape. It was carefully oriented to the vertical direction and proportioned right at the beginning, so the rest was easy. The initial shapes were drawn in very lightly, just to give me something to relate everything else to. Again, this is an example of visualizing the finished drawing before you start to work. Stare at the model until the image is burned into your mind, then look down quickly at your paper. This works better after you have some accurate information down first. The bigger the first piece is, the easier it is to see your next addition. That is why getting the torso down accurately first is a great way to begin, and it's often the easiest thing to get right, too.

Now take a look at the little drawing. The first thing you will probably notice is that the initial bean shape is oriented differently in relation to the vertical than the big drawing. Even this slight deviation gives the pose a different demeanor, but you can get away with that. You cannot get away with the next mistake, which is the same principle as the foot placement rule that I explained earlier.

Here's what's wrong with the small sketch: In the more accurate large picture, you can see that the model is slightly turned away for an angled rear view. Her knees are deeper into the picture plane than her feet. Remember the trick of feet? In the original pose, the model's knees and feet were both on the same level surface, so in the drawing, the knees should be higher on the paper than the feet. In the small sketch, the knees and the feet are flat against the same horizontal. The only way this could happen in a real pose is if the model had her legs spread apart, bringing the left knee out closer to the viewer than her feet.

Compare the two drawings. Notice that the figure in the big drawing is clearly positioned squarely on the floor. The one in the small drawing looks wrong, as if the legs are spread out rather than being together.

Now, as I look at my work in a critical way, I just noticed a mistake on the big drawing. The leg in the back is too long. The knee should be almost a quarter inch farther back. Once you notice the error, it becomes quite disturbing.

Note here that I treated the hip area and the thigh, along with the lower leg, as one big simple shape when I roughed them in, as you can see from the small sketch. Again, putting the big simple shape in first makes it much easier to place everything else. And finally, little things—the flattening at the top of her heel, suggesting the softness of her buttock—are the things that give the feeling of life to a sketch.

Subtle points can become critical when you look at your drawing later.

Drawing from a Draped Model

On occasion, you will get a clothed or draped model to work from. You can even do this kind of drawing using a friend or family member as your model, as I did here, if he or she will hold still long enough. (Ask your model to wear solid-color clothing—it is less distracting.) Drawing a draped model offers a great opportunity to see how the smaller shapes fit into the bigger shapes like a puzzle, and all work together to unify into one.

Shapes have a basic, general orientation. They appear to be basically horizontal, or basically vertical, or basically diagonal. I look for the orientation as I start a drawing. I also look for action lines from which I can build shapes. In the first sketch, the first line I put down was the sweeping curve from shoulder to hem.

Study the drawings to the right, and see if you can understand the logic of progression in the order. Every pose is different and offers many possibilities, and no two artists working from the same pose will have the same progression. You must come up with a way that works for you. Just be logical about it.

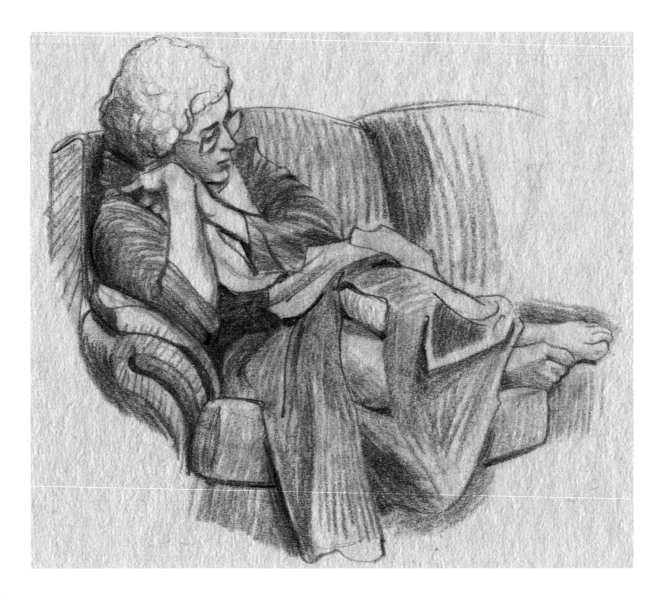

I always start with the most obvious shape and look for a vertical line to help orient all the lines to follow. If there is no obvious vertical, I look for an important directional, or action line (in this case, the shoulder-to-hem line), and put that in to give me an accurate base to work from.

I enclose the shape as accurately as I can, relating everything else to the first accurately placed line. In this case, I drew the whole shape of the robe. Note that these are all very simplified lines, loosely creating the big shape.

Then I add the hair shape along with the face by carefully noting their position in relation to the shoulder line and their size relative to the first big shape.

Now I was able to place the hand and wrist accurately by her face, and noting where the elbow sits in relation to these, I can rough in the triangular shape of the whole arm. It is easy to judge where to place the other arm and the towel shape on her lap. All of the other bigger shapes are added, noting their positions and sizes in relation to the shapes already down.

At this point, I carefully compare the shapes in my drawing to those of the model, and since the drawing is very light, I can make any necessary changes.

From here on, it gets increasingly difficult to see this drawing as a flat pattern. But if the basic shapes are right, you won't be able to go too far astray.

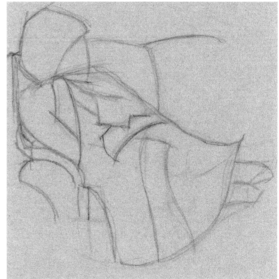

In this phase, I am still looking for smaller shapes and how they fit into the whole scheme.

This is about as far as I need to go before finishing this drawing by adding some darker values to add depth and to separate the shapes. Look how, in the finished drawing, the direction of the lines that make up these dark tones follow the form underneath and emphasize their solidity. Also, some of the edges are softer than others in the final drawing; this adds to the dimensional effect.

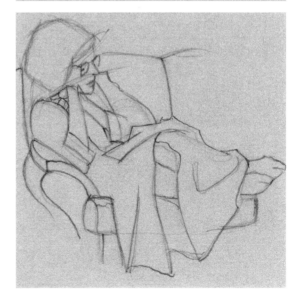

The Silhouette

Since we know that shapes in nature have no outlines, it is strange that we generally start our drawings with outlines to define our shapes.

I am now offering you an approach to starting a drawing that is so logical (and simple) that I wonder why most artists do not use it. It is likely that we avoid it because we mistakenly think that putting a roughly defined tone on our clean sheet of paper will somehow mess up everything before we even start. Let go of this fear!

Here is the approach: Try laying in your figure without outlines. Use the flat side of your drawing tool to get a light tone and go for the big overall shape of your model. Don't bother about modeling at first; just compare your shape to that of the model, using a light, flat tone. Notice how easy it is to compare these "unoutlined" shapes to the shapes you see on the model. Keep it very simple; just get the proportions and directions of the big shapes right.

Why does this work? Because it is far easier to judge your shapes when you are comparing shapes to shapes than when you are comparing outlined shapes to shapes. Since the figure is lightly colored, rather than pure white, the light overall tone you get when you start this way is logical, and you can always lighten areas more with a kneaded eraser or cloth, adding to the solidity and unity of the figure.

Now work into your figure with detail, lines, or modeled tones. Your drawing will quickly start looking solid, and it will also be more accurate proportionally than when you use most other approaches.

In this chapter, I have given you several widely differing ways to start your drawings. Don't get all hung up on any one of them; no one approach works for every situation. Just try to understand the logic of these approaches, and apply them where they fit, instead of blindly charging in with your pencil and ruining the chances of seeing the drawing develop into something you are proud of.

When you use the silhouette
approach, as I did in this fifteen-
minute sketch, charcoal is an ideal
medium. It is easily wiped back
and modified as you go along.
Note how the softly rubbed-out
light areas add greatly to the
solidity of this figure.

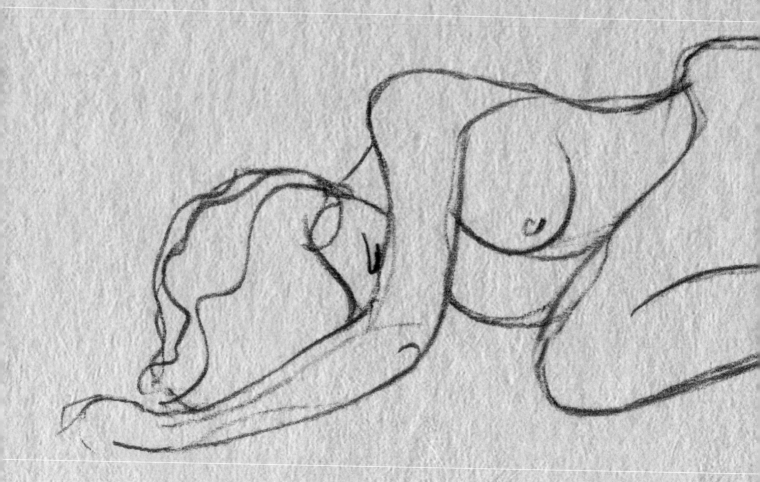

The Magic of Line

Line is the magic tool of the draftsman. A dancing, flowing, freely scribbled line can give far more action and excitement than any finished piece. A searching line, left in as you refine your drawing, will add a vitality to it that you can get in no other way. If drawing is a language, line is poetry. Let it guide you naturally into your own personal way of expressing yourself.

Learning About Line

Line is the magic tool of the draftsman, so subtle and yet so powerful that its use defies accurate analysis. Line will tell you as much about the artist as the subject.

My illustrations for this chapter are totally inadequate. Since I cannot turn on the Zenlike state I need for my best line drawing at will, I had to redo and retouch my dirty, ragged sketchbook drawings. As soon as I changed them, I lost something. For what they are worth, I have included in this chapter the examples that I cleaned up with as little alteration as possible.

A searching, probing line left in as you tighten down on your drawing adds a vitality that you can get in no other way. A dancing, flowing, freely scribbled line can give far more action and excitement than any degree of finish. Sometimes a single line flowing in the direction of an arm or leg is all that is needed to suggest the whole thing. (This is a particularly good example of the viewer wanting to add his or her details to a work of art and to participate in its creation.)

To me, little scribbles done on the spur of the moment are often greater works of art than a finished painting. Study sketches by Rodin, Klimt, or Matisse, or in more recent times, drawings by Robert Fawcett, to see the expressive power of a simple line. Ingres was a master of the controlled line; he contended that a sensitive contour outline could convey all the information the viewer would need to understand the whole form.

I wouldn't even attempt to explain how all this magic works. The secret undoubtedly lies deep in the recesses of our minds. But I do know that if drawing is a language, line is poetry. It is the one thing that can guide you away from copying things mindlessly and pull you naturally into your own personal way of expression.

After you have drawn long enough, you will reach the point where you have gotten all you need from drawing accurately. You will begin to emphasize your own personal feelings about the subject. You will simplify, distort, and compose your drawings without a conscious effort. Then you will then be drawing a visual poetry that others can understand, and line drawing will play a major role in the transformation.

True appreciation of the expressive powers of line came late in life for me. I was always more fascinated with tone, edges, and color. Today, I mostly use a broader line with some

tone to emphasize the form. But on those rare days when the thin, expressive line begins to behave for me, I feel as if I could do anything. It is almost as if my hand is operating independently of my mind. It is at these times when I know exactly what Rodin and Modigliani were searching for in their later works. I also know that the pleasure is in the search, and that the goal will never be reached.

Unfortunately, this feeling of power and control comes and goes. Some people do this kind of out-of-body drawing naturally; some cannot do it at all. If you have this gift, nurture it. It is the closest you will ever come to making pure art. One interesting side effect of this state of mind is that I am never disappointed

in the drawings that result from it, as I often am when I look at my work later.

When you have progressed to this higher state of line work, you no longer concern yourself with accuracy. In fact, if you do, you are guaranteeing a failure. If you have trained yourself to see the important things, they will assert themselves without coaxing. This type of drawing simply will not stand for intellectualizing. It has to be done quickly or not at all. Take a careful look at the drawings in this chapter. They are distorted and the proportions are all wrong, but something better than accuracy has taken its place, and these drawings are the better for it.

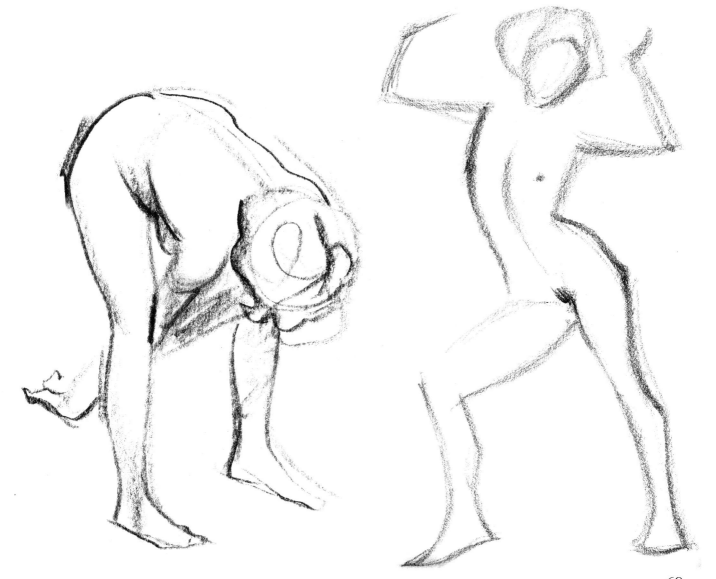

Using Line to Communicate

Here are five more examples of the power of a simple line to communicate with the viewer. From the rapid-fire examples at the top of the facing page, to the more controlled lines of the drawings on this page, to the nervous, unsure lines that you may see in other works, each sketch has a unique message about the subject as well as the artist.

In this book, I am focusing on the basics of realistic drawing. But here, as we discuss line, we are on the edges of something bigger. The possibilities for creativity with line are endless. If you want to delve deeper

Line is basic, and yet it can take you to the greatest heights of artistic creativity.

into the expressive qualities of line—and I urge you to do so—study the works of Matisse, Modigliani, and countless others who experimented beyond pure realism. Even a few top caricaturists and cartoonists have taken this form to great heights.

The drawings on these two pages barely scratch the surface of what I am talking about. Even though they are fairly literal, notice how they are so simple, and yet convey so much information. I hope they spur you on to experiment much more with line.

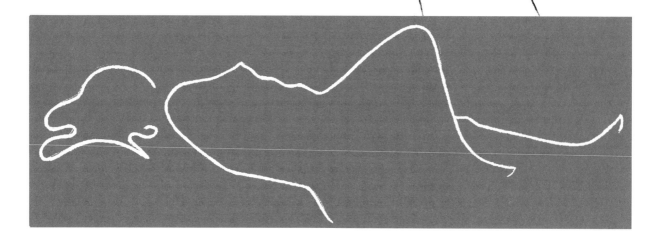

This ten-minute graphite stick sketch
is an example of a very limited use of
tone on a drawing that is predomi-
nantly line. The added tones
boost the form slightly in a
few selected places.

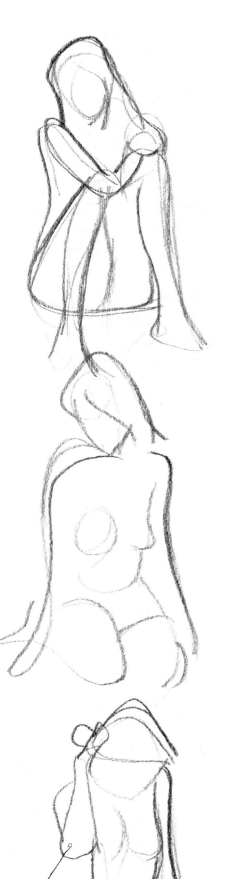

Line and Gesture

As you practice with line, trying to free your mind so that you can enter that higher state, try drawing gestures—the attitude, the pose, the moment of a model. Take no more than thirty seconds to capture the whole thing. Just go for the gesture; the simpler you can "say" it, the better. Look at the model and let your pencil flow around and through the action. Let yourself go and feel the movement. Do not worry what your drawing looks like. Let the shape and action of the pose influence you. This relaxation is the secret to getting life in your drawings.

Drawing the Ghost

After you have practiced getting your early drawings accurate, try "capturing the ghost" to work on your line skills and to improve your ability to see more simply.

If accurate observation habits are not yet a part of you, you will need to work a bit slower because you want to get as close to the orientation and proportions of the model as possible.

To capture the ghost, think of the shape of the hole that would remain in the air if the figure were to suddenly disappear, and draw the hole before it fills in. (A talented fellow artist once said this, and it opened up a whole new way of seeing for me.) Next,

imagine that the shape you just roughed in is a piece of clay and sculpt it into a finished piece.

Both of these powerful pieces of advice will put you in the proper mental state as you draw. Neither of them will allow for any early focus on details until the big shapes and the crucial lines are in. Remember, if you leave in these earlier shapes as you work instead of erasing them, the quickly drawn enclosing shapes will add immeasurably to your drawing. Just keep them light. This is a good attitude to adopt when starting any drawing..

The Flow of Life

Organic forms have a sense of life. What gives a drawing its sense of life is not just smooth, flowing curves but, more importantly, the relationships between those curves.

The muscles all flow together and into the bigger forms to add to the beauty and movement of the whole figure. This relationship, this sense of movement and wholeness, needs to be felt, not intellectualized. Instead of allowing anatomical considerations to blind you, emphasize the flow of life in your drawings: Look for the long forms that take on a feeling of life as the sense of energy flows through them.

Some forms—for example, an *S* curve—give the feeling of life. The "flow of life" is the reason an *S* curve feels alive: The shape mimics the human form in a nonrealistic way. When you start a drawing, you need to establish the simple basic major flow using line. (Often this basic form is an *S* curve.) Once the flow is achieved, play all of the minor forms against it—carefully augmenting the big flow, never overpowering it.

The drawing on the left seems static. The two opposing curves trap the energy as your eye follows the line down to where they come together to cancel each other out.

Move one of the lines up or down and you open up a flow of energy; your eye travels through the shape and continues on. Do you see that the resulting form is a modified S curve? See if you can find more of these dynamic curves in the drawing on the facing page. Look for them on the model in your next session.

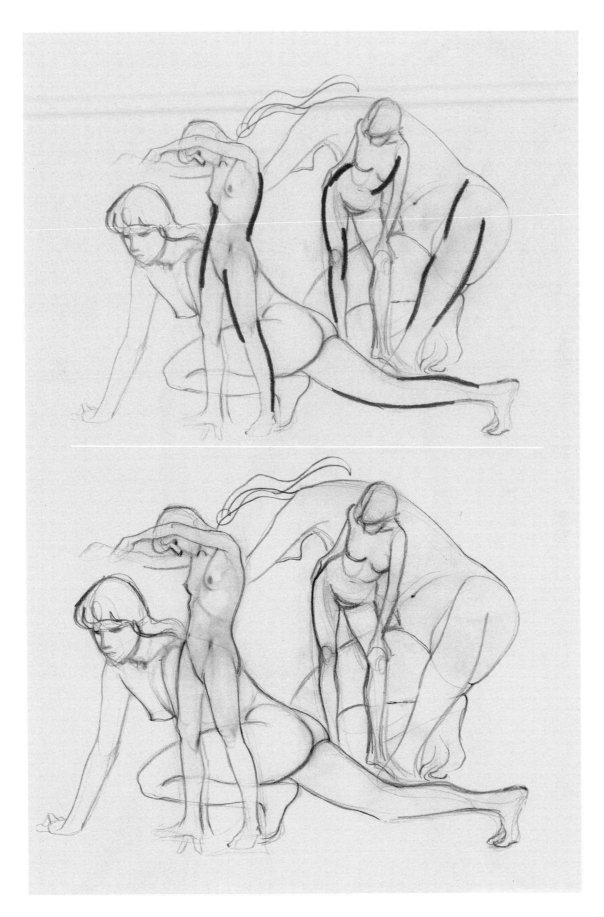

Take a good look at your draw-
ings. Is something missing?
Could it be the flow of life?
Many beginners miss
the balance of curves
that make a sketch
seem alive.

Understanding the Flow of Life

The drawing at left was made so fast that I missed a vital factor in the legs. Can you see the problem? If I had had the proper relationship between the curved lines on the insides of her legs, the drawing would have seemed far more natural.

Both of these are one-minute drawings. The one of the standing woman was done with a soft, blunt Conté crayon on a rough surface.

It is about fifteen inches high. The drawing of the kneeling figure was a soft pencil drawing, about ten inches high. Each of these drawings speaks to the viewer in a different way because of my attitude as I drew them. I will never be able to reproduce them just the way they look here, because I will never be the same person I was when I first put my drawing tool down on the paper.

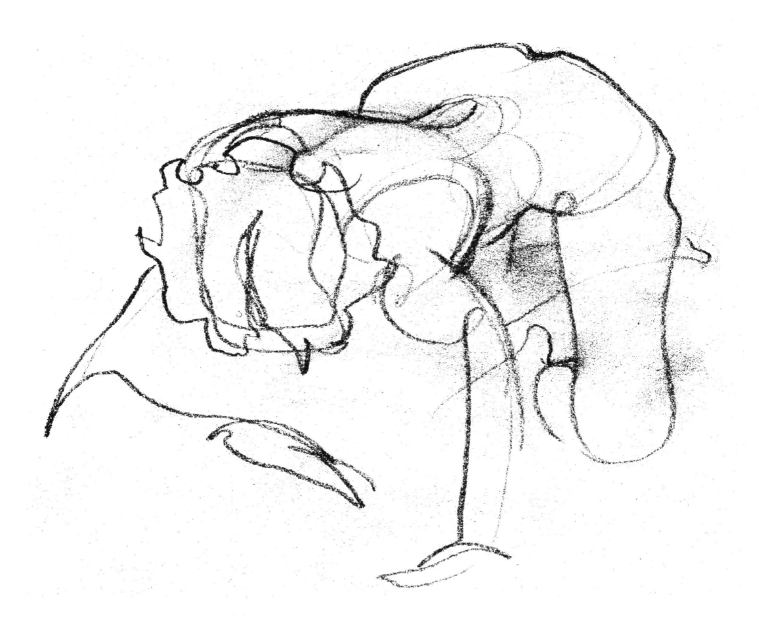

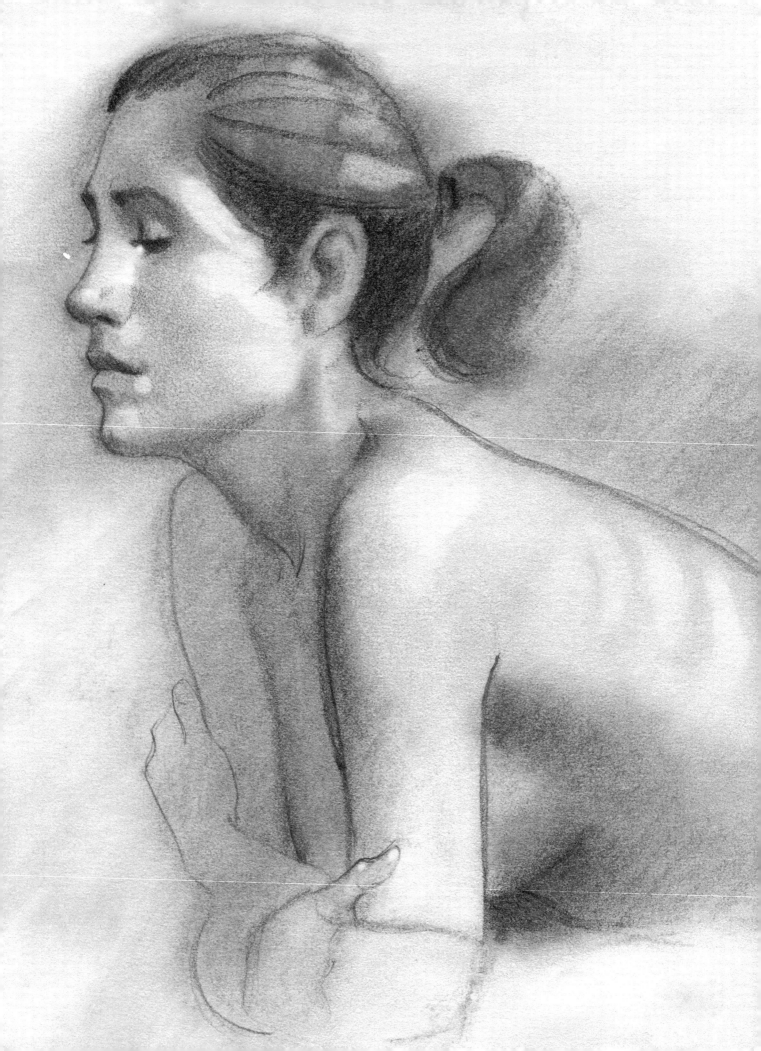

Reading the Language of Line

Line works its magic in many ways. Throughout this book there are many examples of a strong, heavy line carrying the bulk of information about the subject, with areas of simple tone helping to clarify the form, or pushing an area back to amplify the dimensional qualities of the figure, or simply used for design purposes to add interest to a particular area.

There are no outlines in nature. There are only shapes that reveal themselves by their contrast in value to their neighbors. Yet I am sure that most of you looked at these drawings and never gave that a thought. That was line, quietly working its magic on you, most likely without your knowing it. Look at the drawing on this page as an example. Everything depends on line in this picture. If I were to remove the line along the woman's back or arm, the figure would blend into the background and practically disappear.

Most of the drawings in this chapter are pure line. But still it is difficult to realize that you are looking at nothing more than marks on paper, just as you are when you read this page.

Pure line is truly a language, a way of communicating with anyone who can read it. And the real wonder of it is that most people of any age or culture can read this language without having to learn how first. Remember this next time you draw, and try to honestly communicate with your viewers rather than to impress them with your special artistic gifts. Simply tell them what you see in front of you and how you feel about it. Then they will be able to understand what you are saying. Let line help you find your special way of visually speaking.

Drawing for Information

The Old Masters had no cameras to record information for their paintings, so they were forced to make accurate, painstaking studies. This method of gathering information was taught in the academies for hundreds of years. If you want to improve your figure drawing skills, to really hone your observation skills as well as to learn what to look for when you draw, then drawing for information is a powerful tool for you. And as an extra bonus, you will find that it actually enhances creativity.

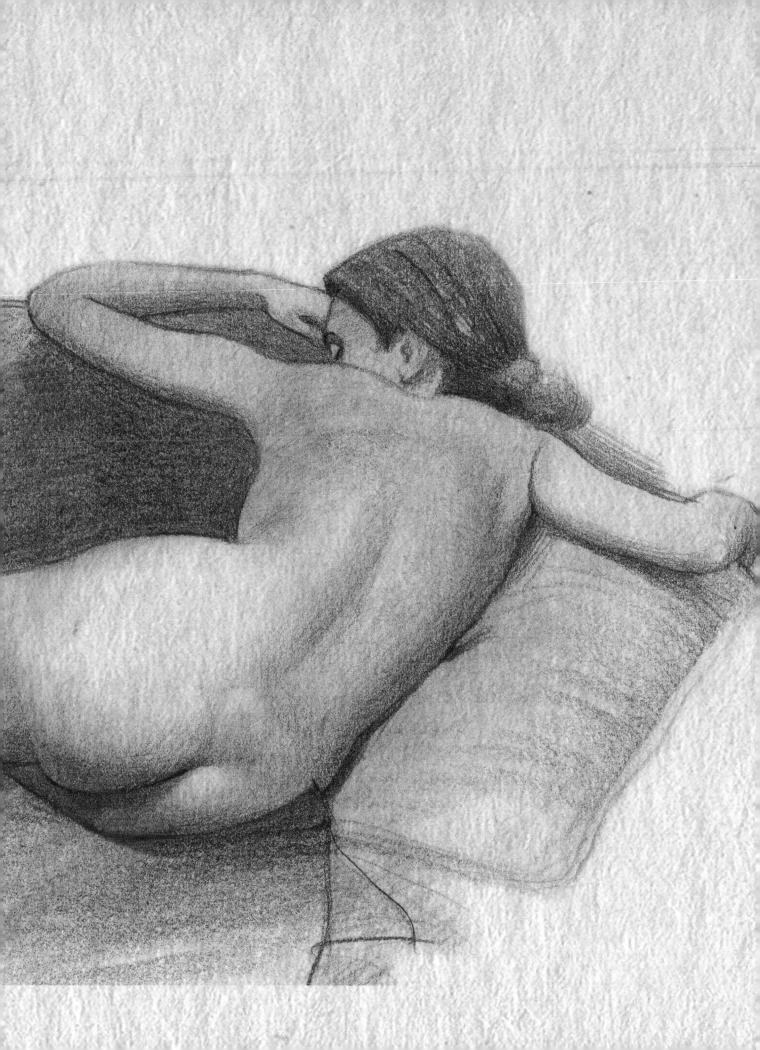

Capturing Information

"If you want a photograph, get a camera." You often hear that tired cliché in art circles. You also hear, "It doesn't have to look like the model." These are both valid statements for the accomplished artist, but they are misleading for anyone learning to draw.

If you are satisfied with the improvement in your drawing skills, you may not need this chapter. But if you are thirsty for knowledge, this well is deeper than you ever imagined.

The Old Masters had no cameras to record information for their paintings, so they were forced to make accurate, painstaking studies of their subjects before they could paint them. This method of gathering information was taught in the academies until considerably after the Impressionists made their mark—which tells us that many of the great innovators of the twentieth century were still using the traditional method of gathering material for their paintings even after the camera became available.

To improve your figure drawing skills, you need to have a focus when you begin to draw. Most of us start drawing with no specific intention other than to get a pretty picture, or we draw simply for the pleasure of drawing. I think this attitude should be reserved for the artist who is satisfied with his or her ability.

Ask yourself what you want out of this particular session. Are you interested in the light effect? Maybe you want to study simple shapes, or you feel your gesture drawing needs work. Any area of improvement is a legitimate focus during a session. If you want to hone your powers of observation as well as learn what to look for when you draw, drawing for information is a powerful way to do it.

In this chapter, I am suggesting that you occasionally approach your drawing sessions with the idea that you might ultimately want to make a finished painting from your drawing. You may never want to, but that's not important. Just try to draw exactly what you see.

Don't add anything, don't try to get "arty," just literally describe the model pictorially as accurately as you can, with as much detail as you can get in the time you have. This is your focus for this particular session.

The beauty of this approach is that it teaches you what information you need to capture to create a finished painting, and it forces you to organize those pieces of information sequentially, in order of importance. In other words, it teaches you to think selectively. That training carries over into all your other work.

This process will be very frustrating at first, because it will be practically impossible to get everything you want within the limitation of time you usually have. But don't worry: The training you get from struggling to get everything you need will eventually force you to be selective. No matter what your drawing looks like, you will have gained something after one of these concentrated sessions.

Drawing for information is a powerful way to develop proper observation habits. It is as useful for shorter poses as for longer ones. I approach most of my drawing sessions with this attitude now, and after years of stalemate, I can really feel the progress. I don't care what the actual drawing looks like. (Frankly, most of them come out quite overworked!) I will use any technique to get the information down, including rubbing, smudging, mixing, changing mediums, or anything else. I am not producing art, I am taking information home with the idea of working from it later. If my study doesn't look like the model, I am disappointed.

Contrary to popular belief, this practice does not inhibit creativity. It frees it up. Try it! Although you need to continue with it for some time, if you stick it out, the results will amaze you. The actual act of doing the work will help you sort out the information that you need, and the order of importance. Just keep at it!

This twenty-minute sketch in pencil is an example of drawing for information. No attempt was made to do anything but bring back enough information to make a finished painting.

The exact contours and proportions, the way the light worked on the model, her particular body, the lightest lights, the darkest darks. All of these pieces of information, and more, were considered and rendered exactly as they looked to me, with no artistic embellishments.

The result is a rather dull, academic drawing, but I got far more from approaching it this way than if I had tried to bring home a masterpiece.

Using Shorthand

Since the drawings on these pages were done with the intention of doing more work on them later, it was important to get all the information I needed in the time allotted. The model offered much more than I could get in this time, so I had to be selective and get each bit of information in its proper order of importance to me.

Certainly these are not inspired drawings—but they do contain enough information for me to work from. The real value was in the concentration I had to use to make them.

When you copy a pose to capture information, you have to make certain concessions. In the drawing below, I used lines to give me accurate contours, even though I saw no lines on the model.

I use this technique often, because there is rarely time to waste rendering backgrounds or the delicate tones needed to separate the figure from the background. The lines becomes a kind of shorthand for me as I gather information.

This pencil drawing was made from a one-hour pose.

Although I try not to exaggerate things when I draw with the intention of gathering information, it often happens unintentionally.

This model is the rare female who displays anatomical structure clearly. She is a runner, quite lean, and the musculature in her back is evident. As a consequence, I got carried away and overdid it slightly. However, having too much information is better than not having enough information. If I wanted to use the drawing to make a painting, I would compensate as I worked from the drawing.

This charcoal study was made from a one-hour pose.

This Conté crayon drawing, which I made in about one hour, is another example of using lines to clarify contours and edges. Care is needed when you use lines for this purpose, because the edges on forms vary in softness, from sharp to soft, and occasionally are completely lost. If you make a hard outline that is equally weighted all the way around, it looks like a wire surrounding the figure.

The Test of Time

One day, quite a few years ago, I was looking at a book filled with incredible landscape drawings by Rembrandt. I realized that one big difference between the artists of that period and ours is the fact that they had no cameras to bring back information for their finished paintings done at the studio. In fact, everything, whether it was located in the studio or not, had to be carefully drawn first before it could be painted. And in most instances, the information had to be gathered in a very limited time.

Rembrandt had developed this ability to such a degree that his little landscape sketches are masterpieces on their own. They tell you everything about what he was seeing with an awesome simplicity. He had developed his own shorthand and needed very little information.

I decided to experiment. I would work like the Old Masters. So for several years, I drew only for information when I had a model to work from. I tried to get the most important information down first, as though I would be making a finished painting from my drawing. Then I continued to add details in order of their relative importance until I ran out of time. This often led to overworked, uninspired drawings, but for a long time I paid little attention to artistic merit because I was interested only in getting as much information as time would permit.

The results were almost immediate. I was forced to draw as accurately as possible, and I quickly learned that I had never before really known what accuracy meant. I also had to make lightning decisions, calculations, and comparisons. In other words, I was forced to see and notice things I had never noticed before. I began to take these drawings home to finish or redraw, and I quickly found that you cannot finish an inaccurate drawing. As a result, I quickly developed my ability to see accurately and to weed out unimportant details.

I also learned that when you concentrate on describing the model instead of fussing over technique or worrying about what the finished product looks like artistically, you develop your own style very quickly, without conscious effort. The creative "arty" stuff happens automatically. We try and try to be contemporary in our work, looking for some elusive line quality or another trendy style, when all we need is an honest attempt to describe the model in front of us.

My own innate style of drawing leans toward solid realism. This method of drawing for information has helped me develop an appreciation of the more nonobjective approaches to drawing, as well as the more contemporary ways of seeing the design aspect of things. I really don't think this could have happened to me without the discipline that the struggle to draw exactly what I see has given me.

But what about you? Can you approach drawing for information with an open mind? Sadly, those who need this chapter the most will be the ones who resist it the hardest. They are the artists who have struggled the longest without results—so long, in fact, that they have lost the ability to see their own work objectively.

Learn to prioritize and use all your time with the model effectively.

I made this pencil drawing in one hour.

Use Time Wisely

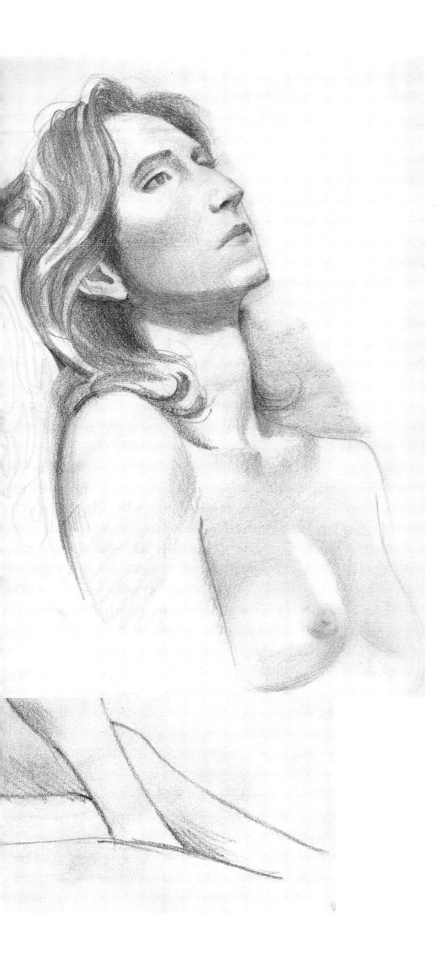

In the classroom, remember that you want to use all the time you have with the model. How long is your class? One hour, two hours? And it is probably held only once a week. Part of drawing for information is time management. Get the basics first, then the big pieces, then smaller and smaller details until the time runs out. Prioritize, and use every moment to best advantage.

Here is an example of getting as much detail as possible in a limited time. This pose was for thirty minutes, so I got the basic information on the whole figure down first, then decided I needed better information on the head, hands, and feet. That is why I made the little detail studies. If you feel you are weak in an area, you might want to leave time for specialized work toward the end of a pose. With my large sketch and smaller studies of the hands and feet, I came away with a clear picture of what I would need to finish this piece later if I wanted.

There was time left in the pose, and I was not satisfied with the likeness I had gotten. So I used the remaining time to do a more careful portrait of the model. When you feel you have enough information to finish your drawing later, take a moment to assess your work. Are there any areas you would like to improve? Use the time you have left to do a hand study, a full-length pose, a head study.

Above all, use your time effectively. Before you go to class, think about the areas you would like to focus on, and work on those areas. This is your chance to grow and develop as an artist.

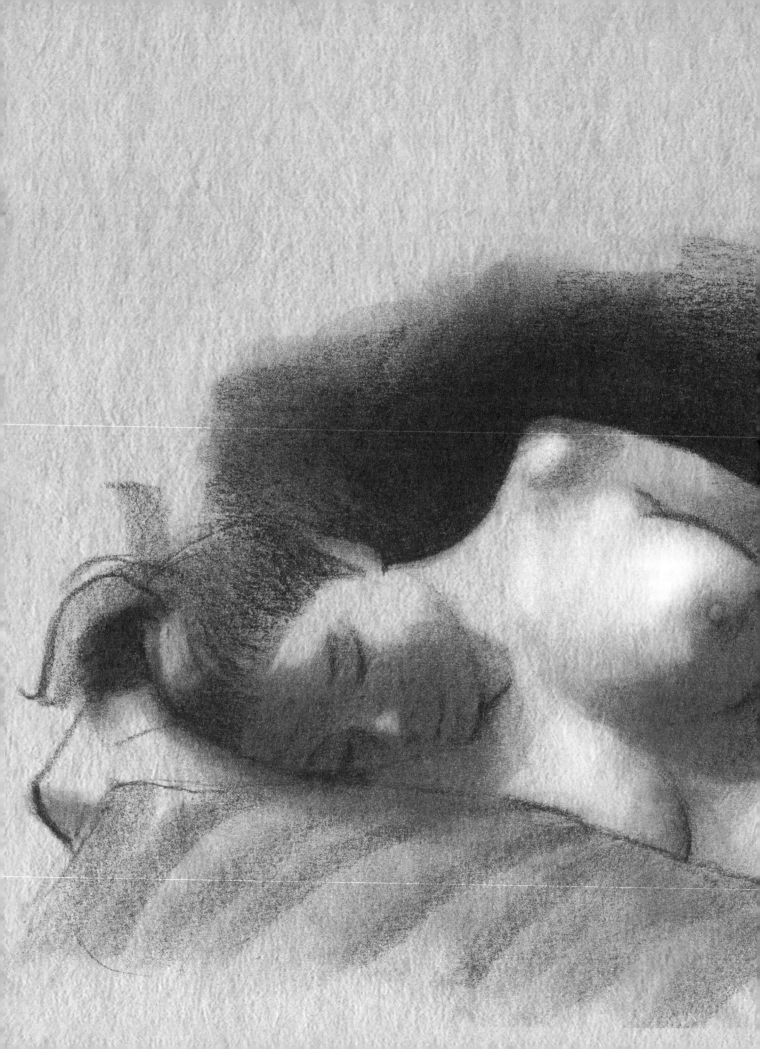

Light and Form

Learn to understand light, and use it to help you see shapes. Many studios have horrible lighting—but when the model is well lit (like this pregnant woman), students will see an almost magical improvement in the quality of their work. A single source of light, ideally daylight, coming in on the model from one direction only is best. Shadows can enhance your work and bring new elements of shading and form.

Simplified Light and Shadow

Good lighting on your model will help you understand shapes and forms. But let's start with an explanation of different types of lighting and how you can use them.

The ball on the left is the traditional illustration of how light works on a rounded surface. It is an accurate depiction of the light, halftone (those areas of tone that fall between the light areas and the shadows), and shadow areas on a white ball in light.

We can tell from this drawing that the surface of the ball is fairly smooth, not rough or textured, not glossy or shiny. We can also understand the roundness of the surface in the light areas as well as in the shadows. While the halftones are a very important part of the equation, we are going to deemphasize them in the beginning so you can grasp the importance of the separation of the areas of light and shadow.

There is a vast difference in the tonal possibilities in drawing media compared to the actual tonal range in real light. The upper ranges of tone are way out of our scale. You have only to compare a white sheet of paper (our highest value) to the lighter things you can see in nature, and you will realize this limitation.

So for now, I want you to think of only two areas: the area in light, and the one in shadow. They are roughly flat areas of tone. On a rounded surface, the edge of the shadow is soft. On angled surfaces, it is hard. The light area is what the light "sees," and the shadow edge is simply the contour of the object that the light is looking at. Anything the light cannot see is in shadow and, for now, is a flat tone.

On an object of a single color, such as the human body, it is impossible for any-

thing in light to be as dark as anything in the shadow. It is equally impossible for anything in shadow to be as light as anything in light. The only thing in light that can approach the darkness of the shadow is right at the edge of the shadow, where the light softens the shadow's edge.

Take a look at the ball on the right. This is how you should see things for now. The light area is flat, but the softness of the shadow edge forces you to see it as rounded. It is actually brighter looking and appears to have stronger light on it than the other ball.

Shadow areas can be dark (never black), or they can be lighter, depending on the amount of light that is reflected into the shadow area. But the law still holds: Nothing in either area can approach the other in value.

It follows, then, that when you have lighter shadows, the lights will have to be extremely subtly modeled, or not at all, and the sense of form will have to be handled at the shadow's edge. You must be able to distinguish this shadow edge on your model. On a softly modeled figure it gets tricky, but it must be done. Just remember: If the light can't see it, it's in shadow.

So far we have been talking about objects of one color, or value. When we get into multi-valued surfaces, things get more complicated, but the rule still holds. Destroy the separation of light and shadow, and you destroy the feeling of light and form in your drawing.

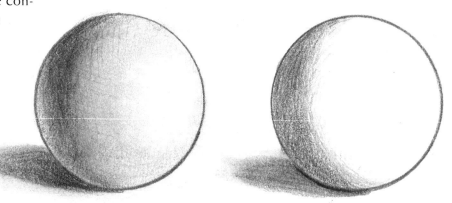

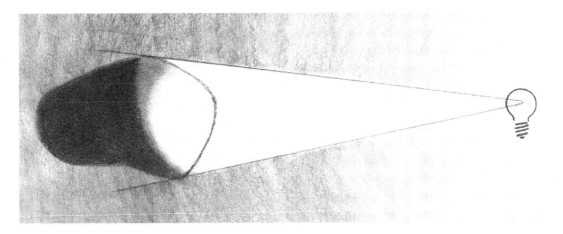

THE PENUMBRA

The shapes in a figure are never perfectly round. The surface of a human being presents itself at many differing angles to the light.

There are some areas that are still in the light. But they are at such an acute angle that they become difficult to separate from the shadow, and the shadow edge becomes softer for a greater distance into the light area. This is what gives the shadow edge its mysterious character.

It is really the widening of the band that softens the edge of the shadow. This band is called the penumbra, and it is here that the texture of the object reveals itself more plainly.

At this point, you are only to consider flat light areas, flat dark, or shadow areas, and the penumbra where it softens the edge of the shadow. If they are correctly drawn, the light effect and form will assert themselves.

FOUR BASIC LIGHTING PATTERNS

There are four basic lighting directions that we will consider for lighting the figure. First, we have flat frontal lighting. This lighting simplifies the form into one simple shape. It is great for studying the big, overall shapes of the figure. With this kind of lighting, we can interpret flat outline drawings as solid shapes, since it practically makes outlined shapes. Think of full frontal lighting as being like the full moon.

Next there is side lighting. Beware of this lighting pattern! If the lighting is exactly from the side, the shadow edge on some shapes will be a straight line, which will effectively flatten out your image. Notice how side lighting gives us a half moon.

Now let's consider three-quarter lighting. This old standby—which gives us the almost-full moon—shows the most form and dimension and is generally the most used.

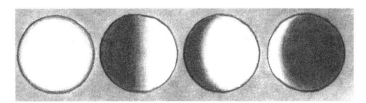

Finally, we have rim lighting. This pattern—as seen in the sliver of moon—comes close to breaking my rules, because you will now need to do more rendering in the shadow area. (Actually, you need to treat it as an area in lower light, which is all shadows really are anyway.) With rim lighting, you can leave the light areas perfectly flat. Don't get carried away in the shadows. You will need to show some form in them, but keep them soft edged and relatively flat in tone.

You may be thinking that there is also lighting from above. But if you turn this page sideways, you'll see that it's just one of these four situations.

Shadow Mapping

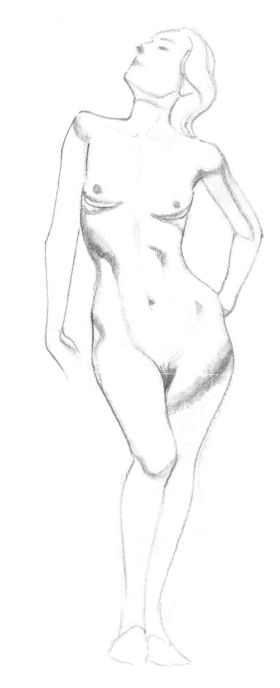

These drawings, illustrating different kinds of lighting and how to map shadows, are much tighter than they need to be. Your drawings will look much better when you put these principles to work in a much freer manner. But these three sketches demonstrate my point, and they also show you how easy it is to carry a drawing to any degree of finish if you start it with the right information.

These sketches also show how to work with ideal lighting. Life drawing classes often have terrible lighting. It mystifies me why most art schools and teachers pay so little attention to it. You can see an almost magical improvement in the drawings of everyone in a classroom when good lighting is substituted for the usual horrible lighting prevalent in so many workshops.

Ideally, you would have a single source of daylight coming in from a skylight; if that is not available, you need one single source of light coming in on the model from one direction only, with all other competing lights turned down or off. If there isn't enough naturally reflected light to lighten the shadow areas slightly, add a reflector in the form of a white cloth, or use a much softer light source coming in from the opposite side of the main light. That's all there is to it.

Many teachers believe that strong, dark shadows ruin the form, but I think that the opposite is true. Hard, black shadows in the wrong place can mask the form, but they are still preferable to double, or multiple lighting, which destroys it.

The first drawing shows an approach that I call shadow mapping. I got all the information about the shape and other pertinent details down quickly in line. Then, with the side of my pencil, I stroke in the edge of the shadow. You are mapping the boundaries of the shadow so you will know how the light fell on the figure when you come back to the

drawing later. In this case, drawing the figure and the shadow map took up all the time there was for this five-minute pose, and then I put the drawing aside until later, when I had more time. Again, this is drawing for information.

Note the character of the edge of the shadow. In some places, it is fairly definite. In others, such as the top of the left thigh, it is blurred to show the acute angle of the light. This is also true on the shadow beneath her rib cage on her right.

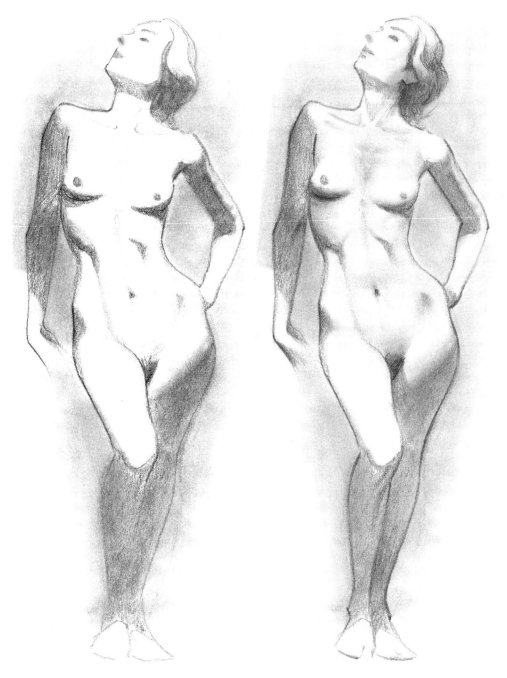

The second drawing shows the stage that you should be concerned with at this time. I took my first sketch home, and now I am working without a model.

The shadow areas were stroked in quickly and smeared slightly to pull them together, and the light areas were left white and flat. Notice that you are getting a strong sense of light on the figure. This is often all the work you need to do to get a good drawing.

The last drawing represents only ten more minutes of work beyond the second drawing. I have added an accent here and there, and worked very lightly in the light areas.

The last thing I want you to notice here is that none of the work I did in the light areas is even close to the value of anything in the shadows—except right at the shadow edge, where a little work was needed to pull things together.

More Shadow Mapping

On this page are two more examples of mapping the shadow areas. Again, I drew the shadow edge only and then set the drawing aside until later.

The first figure is lit from the upper front, putting the bulk of the figure in light.

On the second figure, the light is pretty much from the top; and in this case, it only hits about half of the figure.

Try an experiment with both of these drawings. Photocopy them, then fill in the shadow areas with a tone that matches the shadow line—and watch these drawings come to life.

After you see how simple it is to get the feeling of light with just two tones, try modeling more in both the light and the dark areas. You should now be able to finish up with a minimum of work in either

area, but be sure to keep a balance between the details in both of them. This means a very light touch in the halftones in the light, and softer, simple work in the shadows. Be very selective with your dark accents. Be sure you filled in the whole middle back and both legs in the second drawing.

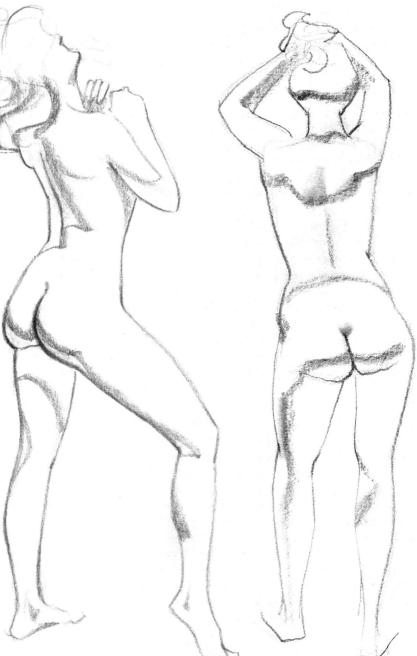

These three ten-minute sketches, drawn in soft pencil, are right out of my sketchbooks. They show the areas of light and dark handled simply and with little detail. I think if I were to work more on any of these, they would lose more than they would gain. Study these, and the ones following, for some of the things we talked about in this chapter. When the drawings are done a little more loosely and freely, as these are, you can see the thinking that goes into them more easily.

Using Light and Shadow

Be sure that you have a clear grasp of light and how to handle it in your drawings, and that you have done enough practice drawing with these flat areas of light and shadow. If not, go through these pages again, because if you do not understand the need to completely separate these two areas, there is no point in going further.

Let's summarize. The figure is a simple, overall light value with very few surface markings, making it ideal for the study of form in light. Since it has some color, it really is a light gray value, but for now, we will let the white paper represent the area in light.

Light has a tendency to spread over skin-textured surfaces and will flatten out the biggest part of the light mass. Most of the form-revealing modeling in the light will be near the shadow's edge. Areas of halftone inside the light mass are lightened by the surrounding light, so they are not as strong as the halftones nearer the shadow. Even the small areas of shadow that fall inside a big light mass will lighten up, such as the shadow under the breast when the rest of the torso is mostly in light. This is nature's way of simplifying and unifying things into simple shapes.

Remember the value chart you made in the first chapter? From making that, you should now understand the limitations in value that you have to work with in all your materials. Using a full range of nine values would mean that you have to work too carefully for fast sketching. It is easier and more effective to simplify your value palette, reducing it to five values plus solid black and paper white.

When you transpose the values you see in nature to your paper, you are extremely limited in your lighter areas. You simply have to leave out most of the values in the light and concentrate on the form-revealing values, or you destroy the relationship between the light and shadow and, therefore, the feeling of light.

Now let's look at the halftones. To start modeling in the light areas, squint your eyes as you do to see shapes. This will also help you to simplify light and shadow on the model. Keep these points in mind:

- Look only for those few halftones that clearly reveal the form, and keep them lighter than you think they are, except right at the shadow's edge.

- Forget those little sparkling highlights. They are reflections of the actual light source, and you couldn't even approximate them with your value range. Besides, unless they are handled expertly, they simply spot up a drawing. As always, when in doubt, leave it out.

- Keep the modeling in the shadow areas flatter and softer than in the light. The strong accents, such as deep cracks between parts of the body or under the body as it rests on a surface, can be put in strongly, but treat the general overall detail fairly softly in the shadows. (One exception to this rule is when your subject is rim lighted. The shadow then becomes an area of darker light, and the light areas are totally without detail, or modeling, except at the edge.) Never let the reflected light areas in the shadow get as light as anything in the light mass.

As you work on your handling of light, you will find that understanding these underlying principles will help make your drawings more realistic and more interesting, too. You will learn more as you practice and discover the techniques that work best for you.

This drawing, made with black Conté crayon in thirty minutes, shows a fairly light shadow area, because light from other sources was getting into the shadows. Note how light the half-tones are in the light areas; they are almost nonexistent, in order to hold the separation between light and shadow.

This drawing, also a thirty-minute sketch with black Conté crayon, shows rim lighting. Note the flat white light (it is simply untouched blank paper) and the simple, almost two-toned rendering in the shadow.

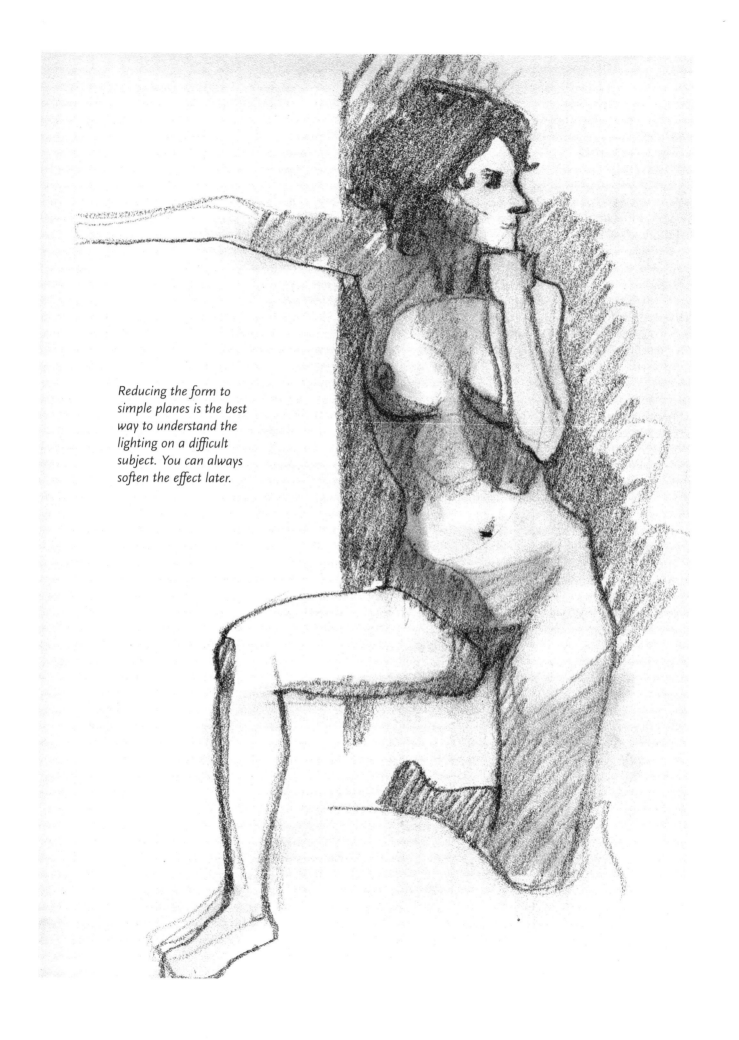

Reducing the form to simple planes is the best way to understand the lighting on a difficult subject. You can always soften the effect later.

Sculptural Modeling

Light is not the only way to show the solid form of an object. It is surely one of the most beautiful ways to describe a scene or figure, but it is not always the best. Artists who mainly do drawings often use line and a way of describing the form called sculptural modeling.

Often in a drawing class, the lighting is so bad that there is no possibility of rendering the light effect on the model. Under these circumstances, you may be content with working in a simple line approach. But if you are really interested in getting the volume of the figure, you will have to resort to sculpting it with tone.

This technique, called sculptural modeling, seems to be a natural thing for most of us, since we often use it unconsciously while working. (In fact, many artists combine sculptural modeling with drawing the light, with good results.) Sculptural modeling enhances the feeling of form in the drawing. It is also commonly used when drawing from the imagination.

In this approach, your eye becomes the light source. Simply leave the areas closer to your eye lighter in tone and keep working down the value scale as the form turns away from your angle of view until you almost reach black. Save your real black for final accents.

It takes a little experience to keep things light enough so you don't use up your whole value scale before you are ready for these final touches. To avoid this, establish both light and dark areas early, and work between them as you progress.

Your eye doesn't really need to be the light source; you can imagine that the light is coming over your shoulder or from slightly above your head with good results as well. Go into fine detail if you like, but start by getting the big forms first and work the details into them, keeping their proper relationship to the whole. Remember, you can turn big masses with the slightest tone. As long as you can see the change in value, it will turn the form away from you. This is a good way to get big, simple, solid form in fast sketches, too.

The sketch here was done with the flat side of a Conté crayon and was purposely kept simple, so that only the big forms were emphasized. This approach works well using random or crosshatched lines to build up your tones. You can get some very solid, convincing drawings if you master this way of thinking.

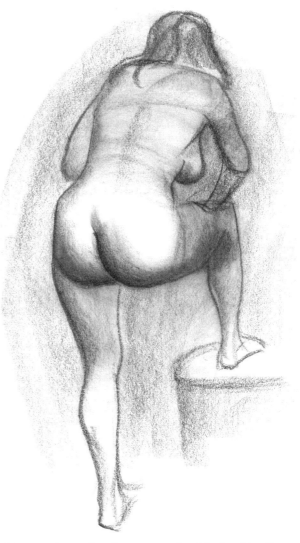

This ten-minute drawing was made with the side of the Conté crayon to sculpt the form. Note that there is only one lightest area. Everything else is slightly grayed down from that. This gives the sketch great power.

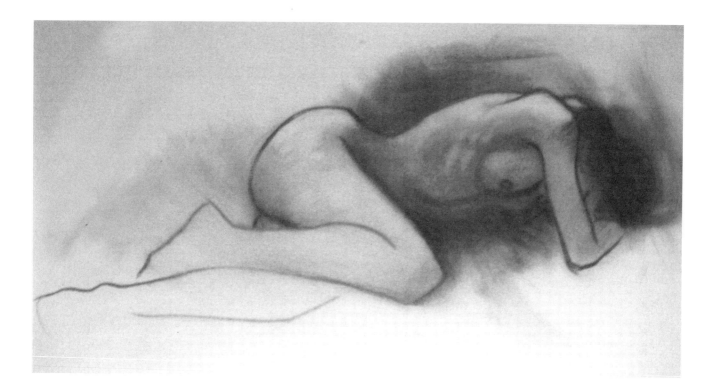

Sculptural modeling can be
quite simple or more complex,
for different effects.

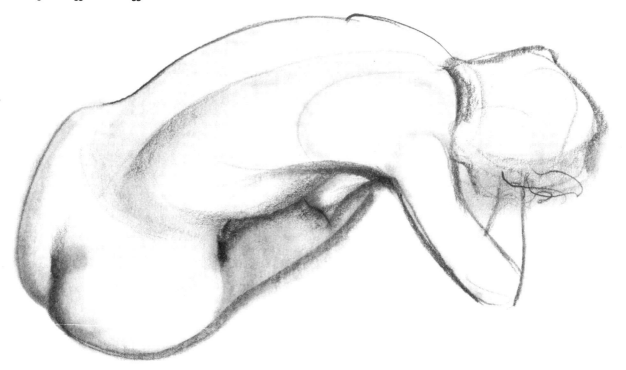

More Sculptural Modeling

Modified sculptural modeling, as shown in the top picture at left, is often used in quick sketching. Even though the light seems to come from above, the planes darken as they turn away from you. The tones are intentionally flattened and simplified. The actual light on the model was confusing, so I resorted to this approach.

The picture at bottom left uses what you might call super-simple sculptural modeling. The line carries the detail, and the tones are used sparingly, just to show the big forms. The forms darken slightly as they recede into the picture plane.

The drawing of the man at right was purely sculptured. The light on the model was so broken up that there was no possibility of getting anything useful from it. So I imagined that my drawing was a lump of clay, and I sculpted it by pushing things back into the picture plane. Because this figure has strong forms within the bigger enclosing shape, I used a fairly dark tone to model them, but note that they are not so strong as to compete with the darks (in this case, the lines) at the edges of the big shape.

This chapter is full of practical infor mation on light and how to use it to give your drawings more impact and expressiveness. No matter what the lighting situation is like in your figure drawing class, you now have the tools to get a good drawing out of every session. Sometimes you work with the light, sometimes you have to imagine the light, but there is always a way to create depth and form in your work.

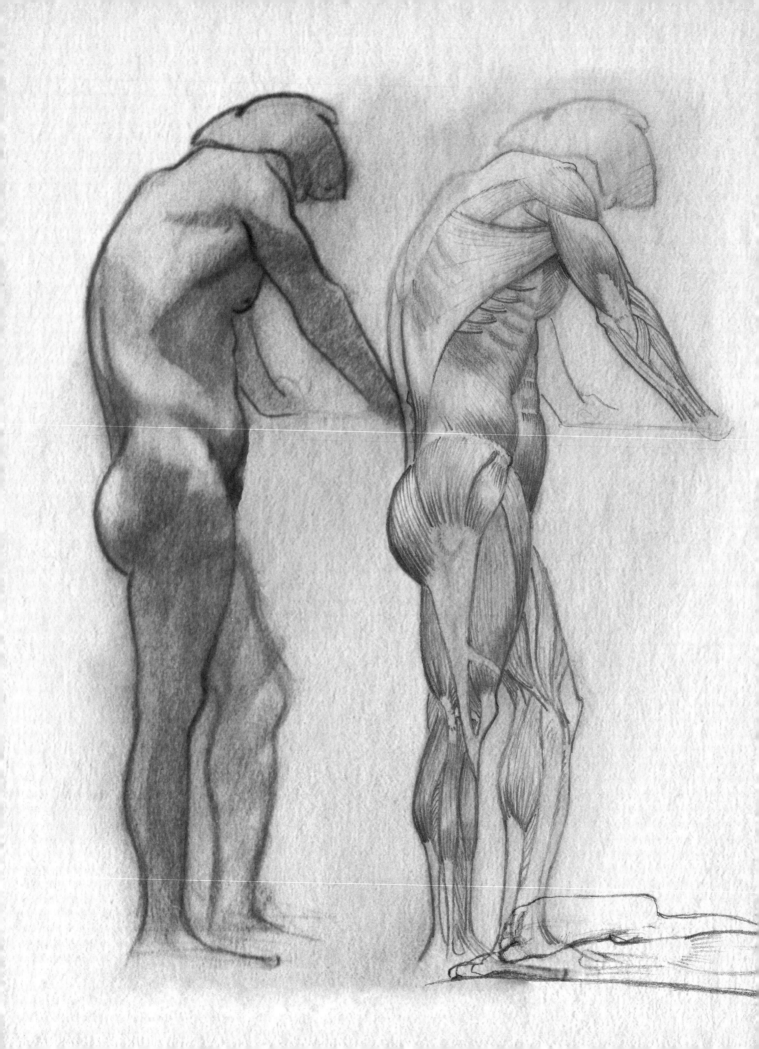

Anatomy

Think of anatomy as a tool to help you under-
stand the underlying structure of the human body.
It is all too easy to get caught up in an obsessive
study of the subject—but here, as with other as-
pects of figure drawing, you need to simplify and
draw only what you see. Remember, the beauty is
in the whole unit. If musculature is overdone, your
drawing will look like a body builder, and all the
viewer will see is muscles! As you draw, learn
to recognize when you have done
enough, and stop before your work
becomes an anatomical study.

Take Anatomy Slowly

In writing this book, I was tempted to leave out the study of anatomy entirely. It is far too easy for beginners to get too absorbed with muscles and bones before they have developed the artistic maturity to control them. So go slowly on this study, and take it a piece at a time. It is entirely possible to draw good figures without a comprehensive knowledge of the muscles, and there is very little reason to learn all their names.

My approach to anatomy gives you my interpretation of the basic muscle masses, with many of the smaller muscles grouped with the larger masses into the simple shapes that have a major effect on the overall shape of the body.

Draw the major muscle masses right over your fast sketches.

I have included the usual charts complete with most of the names for you to look at, but I recommend that you put off working with deeper anatomy until after you get the other basics under control.

I studied and learned all of the muscles and bones, with all their origins and insertions, before I was sixteen years old. That was a very big mistake. It took many hard years for me to learn to see simply again.

With that said, I will admit that if you can keep knowledge of anatomy under control, and if you can use it properly, it will help you see and manipulate what is in front of you like nothing else can. The more you know about a subject, the more clearly you can describe it. However, when the details overpower the whole, this knowledge can destroy the real beauty in a drawing without the artist being aware of it.

Ultimately, if you want to do really detailed finished work, it will probably be necessary for you to study anatomy. But this is a book on basics. If you do reach the point where you would like to work on anatomy more, you will find many excellent, thorough books on the subject.

In this chapter, then, I offer you the minimum information you need to get an understanding of how the body is put together in order for you to draw it convincingly. I will include several of my quick one- to five-minute sketches with examples of the various muscle masses at work. Take some of your own sketches and work over them as I have done, adding the underlying muscles, until you get a feel for these masses in your work. Also look for them—and try to identify them—on the live model or in the mirror.

Here is an example of how you can sketch in muscle masses. The figure on the far right is my original rough sketch, done from the model in one minute.

The other figure is a copy of the original sketch over which I drew in the major muscle masses. This copy was done on a letter-sized piece of paper—a little small to work freely, but it demonstrates the idea. You want to get a feel for the muscular structure in your sketches, even though you don't actually show the muscles.

By working over your simpler sketches in this way, you can tell where you went wrong in the initial sketch. You will also be developing a basic knowledge of the muscle masses.

Keep your drawings looser than I have done here, and work fairly big to get a flow going. You don't need to draw in every muscle, just a few to get a sense of the musculature. Make this project as enjoyable as possible, and stay loose. If you might feel the need to go into much more detail, you could rough in the skeleton first and build the muscles over it. Just don't let things get tedious.

You will see more of these sketches with added muscles throughout this chapter. They should help you see the muscle masses in action.

The original pencil
sketch is a quick
action sketch;
it took one minute.
Because it was so
simple and the pose
was so dynamic, this
drawing was ideal
to work over with
anatomical
information.

The Major Muscles of the Back

These drawings present the major muscles of the back of the body and of the front of the body in a traditional way. Study them, use them, but don't memorize them. You need a working knowledge of the major muscle groups, but you don't need to be a medical encyclopedia.

1 **Sterno mastoid**

2 **Trapezius**

3 **Deltoid**

4 **Infraspinatus**

5 **Teres major**

6 **Teres minor**

7 **Triceps**

8 **Latissimus dorsi**

9 **Biceps**

10 **Brachialis**

11 **Flexor carpi ulnaris**

12 **Anconeus**

13 **External oblique**

14 **Extensor carpi radialis longus**

15 **Iliac crest**

16 **Sacrum**

17 **Gluteus medius**

18 **Gluteus maximus**

19 **Ilio tibial band**

20 **Semi tendinosus**

21 **Biceps femoris**

22 **Gracilis**

23 **Popliteal fossa**

24 **Sartorius**

25 **Gastrocnemius**

26 **Soleus**

The Major Muscles of the Front

1 STERNO MASTOID

2 TRAPEZIUS

3 DELTOID

4 PECTORALS

5 TRICEPS

6 BRACHIALIS

7 BICEPS

8 LATISSIMUS DORSI

9 SERRATUS MAGNUS

10 EXTERNAL OBLIQUE

11 SUPINATOR LONGUS

12 EXTENSOR CARPI RADIALIS LONGUS

13 EXTENSOR CARPI RADIALIS BREVIS

14 TENSOR FASCIA LATAE

15 SARTORIUS

16 ADDUCTOR GROUP

17 RECTUS FEMORIS

18 ILIO TIBIAL BAND

19 VASTUS LATERALIS

20 GRACILIS

21 VASTUS MEDIALIS

22 BAND OF RICHTER

23 PATELLA

24 TENDON OF BAND OF RICHTER

25 PERONEUS LONGUS

26 TIBIALIS ANTERIOR

27 EXTENSOR DIGITORUM LONGUS

28 SOLEUS

29 GASTROCNEMIUS

30 RECTUS ABDOMINUS

Simplified Anatomy

The drawings on these two pages show the major muscle masses grouped and simplified. They are the minimum you need to know about the body to draw it with reasonable understanding.

I am purposely leaving out the names of these masses. You can name them any way you feel comfortable with, or forget naming them altogether. Try to get an overview of these masses and how they interlock and flow into one another. I have numbered them so you can tell which can be seen from both front and back. Just don't get all hung up on fine details.

Some of these masses represent muscles that flatten out sheetlike and reveal the structure beneath them, notably the latissimus mass (14) and the oblique mass (6). These muscles, along with the upper abdominals, show the rib cage, sometimes quite clearly where they thin out and attach to the ribs. Knowing this information will bring life into your drawings and keep them from looking wooden.

Most people have a layer of fatty tissue, thicker or thinner. This, along with the fact that the muscle tone in the average person is less than ideal, tends to hide and blend muscle groups together into smoother masses. So be careful that you don't overdo the separation of these masses in your drawing.

The main thing I want you to understand as you are working from this material is that we are dealing with flesh and bone, not something carved out of rock as anatomical charts tend to suggest. You need to get a sense of the structure of the body, but remember, it is the structure of a living thing. These masses can be soft, hard, yielding, or flexible. They can blend together or stand out, stretch or compress into many shifting forms; but they should always be subordinated to the whole body. You are drawing a figure, not muscles.

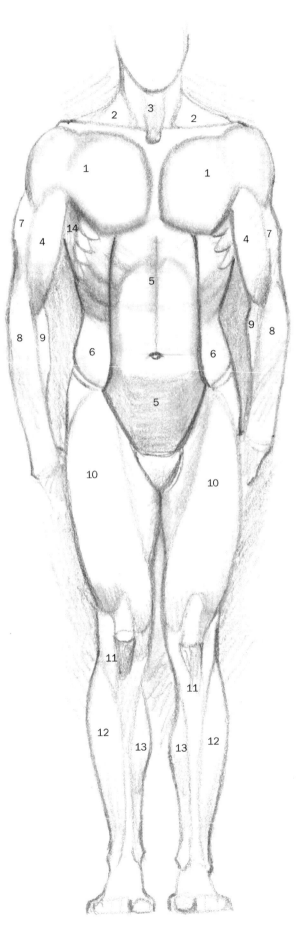

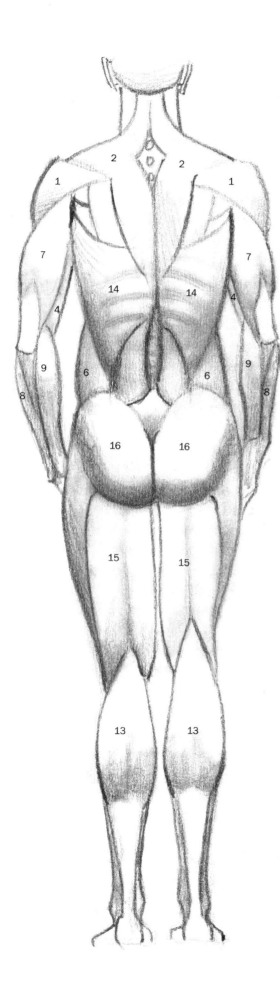

The musculature and masses of the male and female are essentially alike, but the proportions can be dramatically different. The obvious differences are the female breasts and the size of the hips in a woman, generally wider in relation to the rest of the body. The widest part is at the top of the thighs.

The breasts are simple fatty tissue attached to the lower pectoral muscles. They vary greatly in size, shape, and elasticity. Since they have no muscle tissue, they are subject to gravity; consider this as you draw, or the breasts will look artificial.

In addition, the female is usually smaller, and her muscles are not as developed as the male.

The Basic Trunk

The study of anatomy can get just as complicated as you want to make it. When you are confronted with all the little details of the masterpiece we call the body, you can be overwhelmed quickly. Yet like anything else, it can be greatly simplified and broken down into manageable pieces. This simplified information is enough for all but the deadly serious artist who is not satisfied with basics and needs to know exactly how things are put together.

When you eliminate all of the individual bones that make up the trunk, it can be seen as consisting of three basic structural units: the rib cage, the spine, and the pelvis. Looked at as a shape, the rib cage becomes a flattened egg with a piece broken out of the bottom and a round hole at the top. The pelvis can be seen as a bowl with a piece taken from the front. And the spine is a simple, gracefully curved flexible column that connects them. These three masses constitute the major portion of the body. (I have complicated this only slightly by adding the critical bones of the shoulder girdle on the drawings of the oblique masses.)

Your job as an artist is to relate the basic muscle masses from the preceding simplified charts to this structural group. You should be able to see where they attach and fit into it, and how they all come together to form the basic trunk shape. If you like, copy these pictures and draw the masses right in.

Take a closer look at the pelvic bones and see how they can be seen as an open-fronted bowl. Remember that the egg-shaped chest mass is made up of ribs. Look at my drawing of the skeleton and muscles to see the positioning of the ribs, but don't bother to count them. The spinal column is made up of heavily ridged individual bones, and they often show through at two places on the back.

Note the diamond-shaped tip at the base of the spine. This is the sacrum. It is a strong landmark for locating several of the big muscle masses of the back. It conforms to the bowl shape in shape, so take note of that in the side and back views.

The outline of the figure shape around each of my drawings represents a fair coverage of excess body fat. In some models, the outline could come in so close to the bone structure that the rib cage and pelvis bones would show through clearly. In fact, you can almost always see evidence of these structures in your model; be aware of them as you draw.

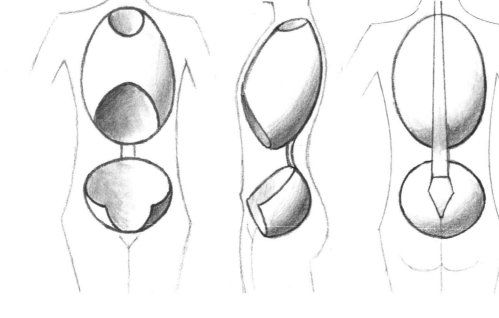

The two big muscle masses in the middle trunk are thin sheetlike muscles that hold in all the inner workings of the abdomen. Weak muscles here account for the potbellied appearance of many people, as the intestines push outward through the opening in the front of the pelvic bowl.

These abdominal muscles are often padded over with fatty tissue, and they tend to blend together into a smooth mass. Both of these muscles thin out at their top connections to the rib cage and can show considerable rib ridging in these areas. Don't overdo this, but don't ignore it, either, because these little nuances add to your drawings.

The material covered here gives you a working understanding of anatomy. You will find that you will automatically add to it a little at a time as you go on. Study how people really look, and gradually relate that to the underlying anatomy.

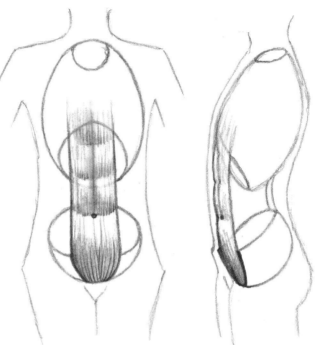

The abdominal mass, number five on the simplified anatomy charts, looks like this in relation to the rib cage, the pelvis, and the spine.

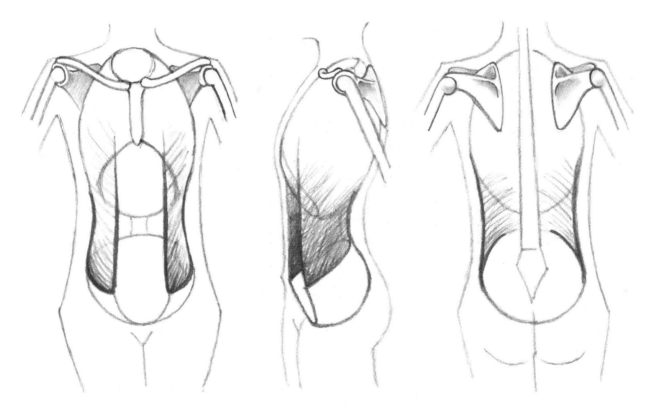

The oblique mass, number six on the simplified anatomy charts, looks like this in relation to the rib cage, the pelvis, and the spine. The bones of the shoulder girdle are shown separately at the top.

Sensing the Underlying Masses

The underlying structure is always there, whether it is defined in muscles or masses. Even in this model, who has enough body fat to cover the underlying muscular structure, the structure must be sensed and understood in order to simplify it into a unified whole.

This drawing should convince you of the need to simplify and to draw only what you see, even though you know what is under the surface. The beauty is in the whole unit. When it is chopped up in pieces, it is destroyed. Think about body builders: When the muscula-ture is overdone, you see the muscles instead of the whole body. The results can be horrifying.

In drawing, the line between an understanding of anatomy and too much knowledge can be a fine one. Be very careful when you tighten up your work; do not go so far that you destroy the beauty of the figure. As you work, take brief pauses to study the overall effect of your drawing. Are you hinting at the musculature or hitting your viewer over the head with it? Learn to recognize when you have reached the stopping place.

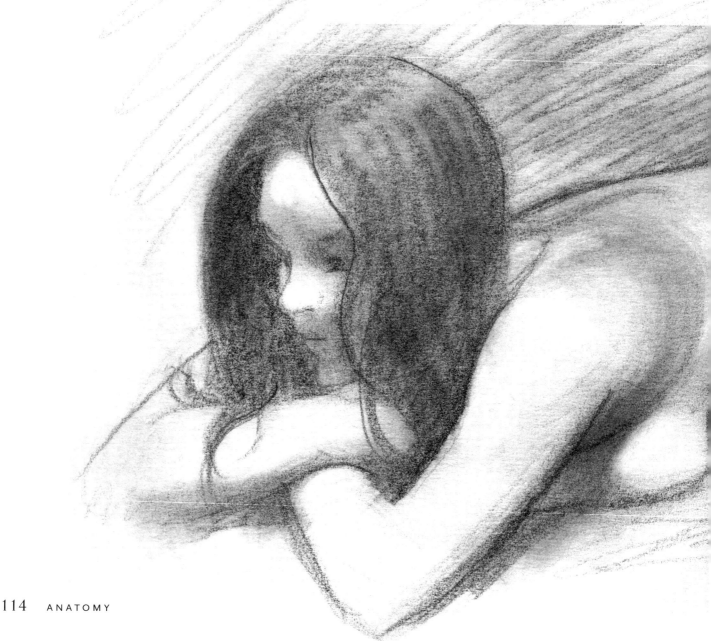

This graphite stick
drawing took fifteen
minutes. The inset
drawing, with
anatomical
structures added,
was done later.

More on Masses

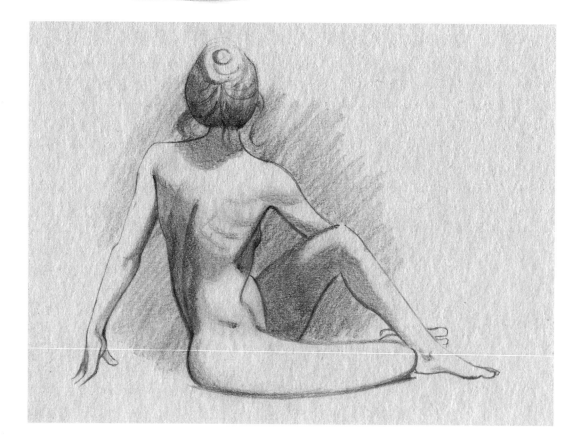

Here is another look at masses. The model for this thirty-minute pencil drawing was fairly muscular for a woman, and so she made a good study for the back. Note the thin sheet-like mass of the latissimus dorsi muscle where it reveals the ribs underneath it. It is easy to get carried away when you have clear musculature to work from, but control and practice will help you produce good drawings. Here again, the bottom drawing was done in thirty minutes in class; I reworked that into the top drawing to illustrate the underlying masses.

Points of Orientation

There are places on every body where the bone structure comes to the surface. They are great points of orientation for the artist to build from. They have been highlighted in white on these two drawings. The points at the base of the neck and at the pelvic ridges are especially important; on the back, watch for the shoulder blades. Look for these before you start to draw; they can be a powerful aid to working out a complex pose.

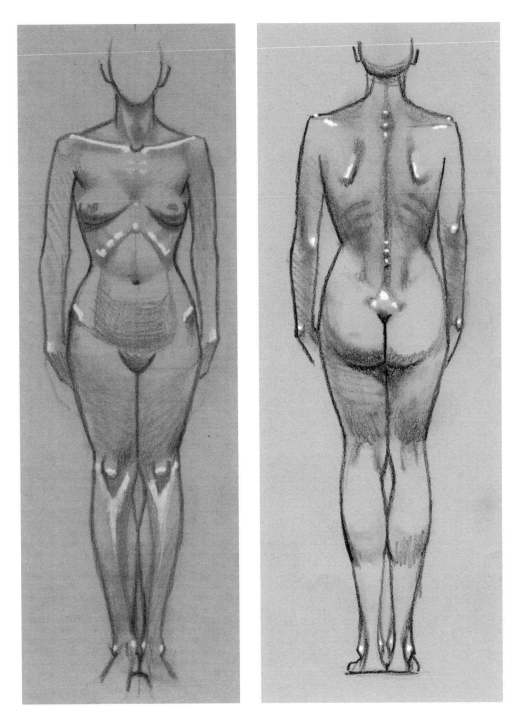

For the Advanced Student

This drawing is an example of how far you can take these studies if you really want to go into an in-depth study of anatomy. From reading my earlier warnings, you know that I strongly recommend that you get a solid base in the other, more important essentials before you get too deep into this study. But I include this example because some artists want to pursue anatomy and find it particularly interesting.

If you do have a special interest, my method of drawing in the musculature on top of your existing drawings is undoubtedly the best way to go about this study. Making the usual anatomical charts, as I have done on the preceding pages, is boring, to say the least. You will quickly tire of doing them. It is far more beneficial and interesting to work on the different poses you get from life class; that shows you how the muscles relate to one another and to the body as a whole. Draw right over your sketches, as I did here. A simple line drawing is best, but you can work over anything that isn't too dark.

This was a ten-minute drawing that I did with a fairly light line, so it worked perfectly. Get a good anatomy book with all the fine details, and keep it handy when you work. When you can do these detailed drawings without the book in front of you, put anatomy aside, unless you are going into medical illustration, and concentrate on using your knowledge to produce beautiful art.

These drawings, originally one-minute poses developed into simple muscle masses, are a gruesome example of what could happen to your drawings if you get too wrapped up in anatomy. Do you see why deep study is not necessary or even desirable for getting artistic results?

The Head, Hands, and Feet

The head, hands, and feet are an important, expressive part of every figure drawing. In this chapter, we will look closely at these elements. There are special techniques for creating distinctive faces and realistic, natural hands and feet; master them, and your work will be the better for it.

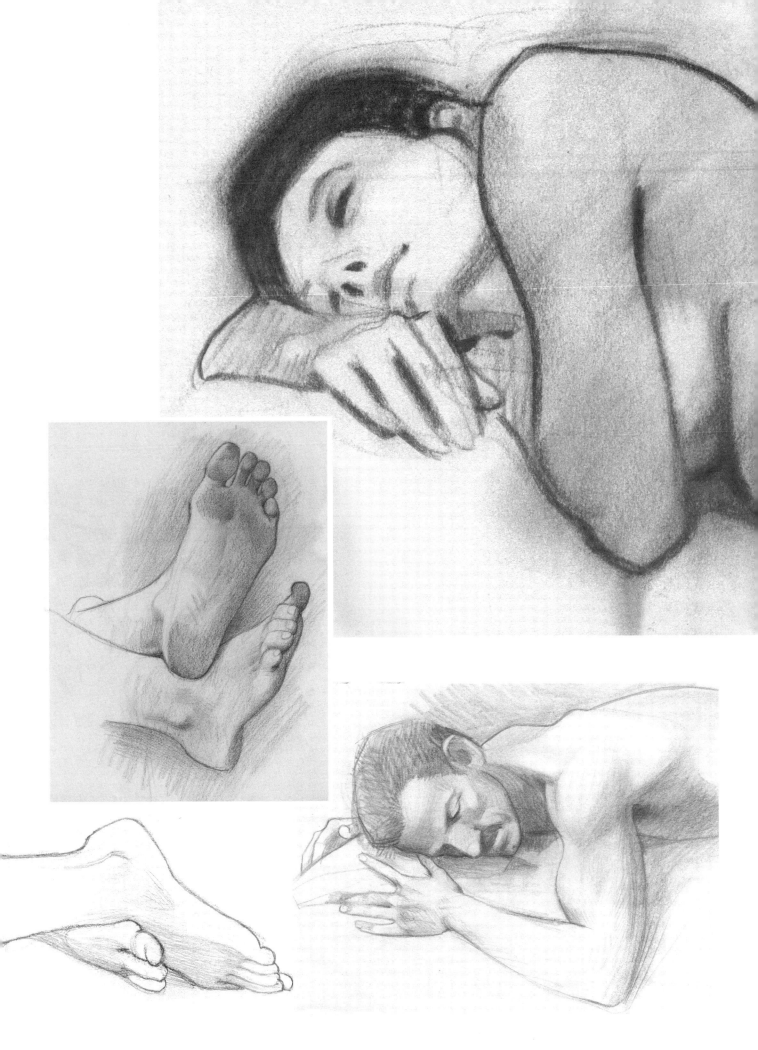

Understanding the Head

The drawing on the right shows you that in sketching from the model, we usually make the head far more difficult than we need to. We have learned to think of the head as an oval, but it is really just another shape that needs to be integrated properly with the body. The hair, fortunately, is usually darker than the face and forms a separate shape that frames the face, making it easier to draw.

Most of us think of heads as ovals and draw ovals first, because the best way to demonstrate proportions is with the oval. We get stuck in that mode of thinking. Even though most artists (and that includes me) often use an oval to make the head when sketching, it is rarely the best way. It is far better to draw the face and hair in as separate shapes initially, exactly as you do with the rest of your drawing to keep the whole figure unified.

However, I do have to use the oval concept to show the basic proportions of the head and the positioning of the features. After you have used this proportional information long enough, its use will become automatic. Then try to start by drawing the big shapes of the face and hair instead of starting with an oval, and you will get better results.

There is an average face map from which all heads can be drawn by studying how your model's features deviate from the norm.

If you will look carefully at the drawing on the right, you will notice that there is no careful delineation of any of the features. They are nothing but black smudges of tone—one more example of your mind supplying the missing pieces. It is strictly the placement of these smudges that makes this a very believable face. The lips are the only feature that show any detail, and even that is minimal. The shape of the face and hair were carefully studied, but ultrasimplified.

Step back a few feet and look at this face. It seems more detailed than it really is. Actually, it is an enlarged detail from a drawing in this book. Originally the head was only one and a half inches high.

The drawing on this page is simply an oval with blobs of dark tone put in the proper places. With a quick finger smear, I set the eyes back in their sockets. No details at all were added. This is often all you need when sketching from the model.

Learn the basic proportions of the head, then move on to viewing it as another shape.

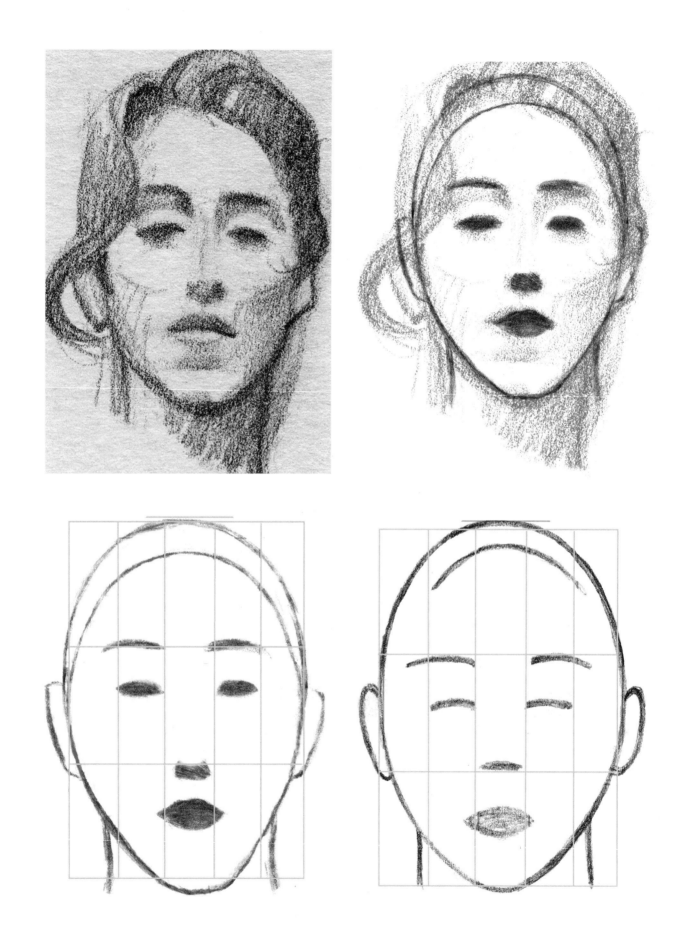

The Basic Proportions of the Head

There is no exact formula for drawing the head, but there is an accepted norm from which all heads may be derived.

The head on the upper left, the same one that was shown on the previous page, was scanned from a full-figure sketch. Let's look at it closely; it shows perfectly how faces deviate from the accepted normal model. It always amazes me how little these deviations usually are. Yet out of billions of people on this earth, no two are exactly alike.

This particular model has a classic face. She is a delight to draw, and yet compared to the average basic norm, her nose and chin are both slightly longer. Details such as these are what give individuality and character to a head.

The next version of the model's face, on the upper right, is a grayed-down print of the first drawing, with some of the hidden lines defined to show the exact feature placement.

Next we have the "map" taken from her face using gridlines. You can see how it compares to the drawing next to it, which is considered to be the basic average face model. The deviations are slight, but they are enough to give this model her special character. These distinctions in position and shape are the things to look for, not the tiny details of the features.

Basically, the formula for the average face map, shown on the lower right, is this:

- The head is roughly an oval, approximately one and a half times longer than it is wide.

- If you divide the face, from hairline to chin, into thirds, the eyebrows will fall at the top division line, the base of the nose at the next lower line, and the chin at the bottom.

- The eyes fall at the midpoint between the top of the head and the chin.

- Divide the widest part of the head in fifths, and each segment will represent either an eye, or the space between or outside of them.

Once you have consciously applied this formula for a while, you will begin to relate your models' faces to the average automatically as you draw. You will no longer need to think about it. This technique can help the faces you draw become individual and unique, because it is based on solid observation rather than rote tricks.

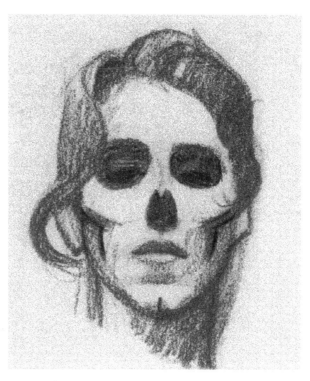

THE SKULL

There is a skull under every head you will ever draw, and it should somehow show through. Sometimes it is pretty subtle, and often it is quite obvious, but it should always be there. If you really want to simplify the drawing of a head, start with an indication of the skull first.

Can you see the underlying skull in the drawing at the top left on the facing page? If not, squint down at the big head at the beginning of this chapter, and it will show itself.

Building on the Structure of the Skull

Let's dump the timid, weak struggle to lay in the head once and for all. The head is really as easy to draw as any other part of the body when it is approached properly. The right way to approach the head is to have a solid concept of the skull to build off. You could probably draw the skull without the features fairly easily. Start with a simple front view, using what you have learned about basic proportions.

Start with a chin dot and three boundary lines to establish the position and size of the head. Now put two smudges, to suggest eye sockets, halfway down the head. Then smear in two slight indents where the cheekbones surface. You are now halfway home to building a skull. Can you see it?

Locate the bottom of the nose with a fairly strong smudge of tone about halfway between the eyes and chin.

Now the lips go in, a little above halfway between the nose and chin. Seem familiar?

Add a hairline wherever it looks right—about a quarter of the distance from the top of the head to the eyebrow for now. Also indicate ears, which line up with the eyebrows and the bottom of the nose.

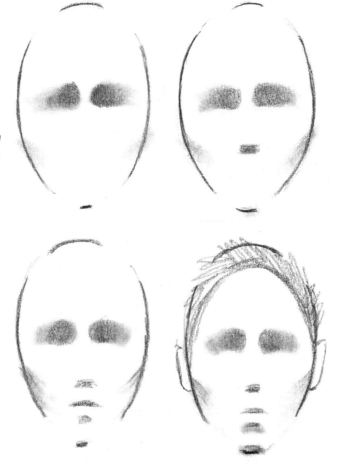

A little more fussing with details and modeling.

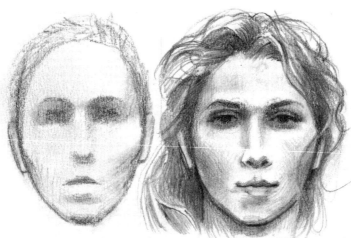

You can now add all the detail and rendering you want, or you can keep it as simple as you like. The head and face will be solid if the simple skull shape was right—and how could you get it wrong?

THE SIDE VIEW

The side view of the head can also be positioned with a chin dot and three lines. Notice that the face from hairline to chin can be divided into three equal segments. The head in this view is wider than the front view. The length is only about one and a quarter times the width.

The ear sits in the rear half of the head. The eye socket is set back from the face line, while the nose sits in front of it. The mouth and chin are on the line.

Again, there is the sense of a skull structure in this view. This makes it easy to feel the solidity, as well as to place the features.

THE THREE-QUARTER VIEW

All of the angled views can be treated pretty much the same as the side view by starting with the chin dot and three lines for placement, but you need to make slight changes in proportion depending on your viewing angle.

Also, a face line is added inside the head. Its position depends also on the viewing angle. The eyes sit back from this line; the mouth and chin are on it and the nose in front of it.

The skull is apparent in this angle as well as the others, making the feature placement much easier.

Try a few dozen sketches using this approach. You'll be surprised how easy it is once you get the basic proportions of the skull down correctly. But remember, this is a learning device, not a drawing system. It can help you when you need it and it's great to use if you don't have a model, but nothing replaces solid observation of the shapes on your model as you draw.

Angled Heads

Severely angled heads are quite another story. They will test your powers of observation to the limit.

Here, starting with a skull image to build on can get you out of trouble. It is much easier to visualize a skull at an odd angle than it is to visualize a head, probably because we see the skull, with its rounded cranium and big simple eye sockets, as a more geometric inanimate object.

With the head at a deep angle, the proportions are drastically altered and you need to compare each new shape as you add it, but the underlying skull will help guide you through. It also helps to reduce the head down to two planes, clearly placing a line separating the side from the front.

These diagrams look at exactly what happens and what you see when the head is tipped at odd angles. This mechanical information is useful only to help you understand what you are seeing; you need to use your powers of observation and draw what you see in order to get beyond this stage.

Knowing what to look for when the head is tipped away, or toward you, will solve half the problem for you. Take a careful look at these two views. What is happening?

In the top view, the head actually gets longer, because the top of the head is added to the face: The ears are much higher up, the distance from eyebrow to eye is compressed, the nose is longer, and more of the lower lip shows.

The shorter bottom view is roughly the opposite. The head gets shorter because the top of the head is hidden: The ears are much lower, the distance from eyebrow to eye is expanded, the nose is shorter and its tip is nearly level with the eye, and now the upper lip shows itself.

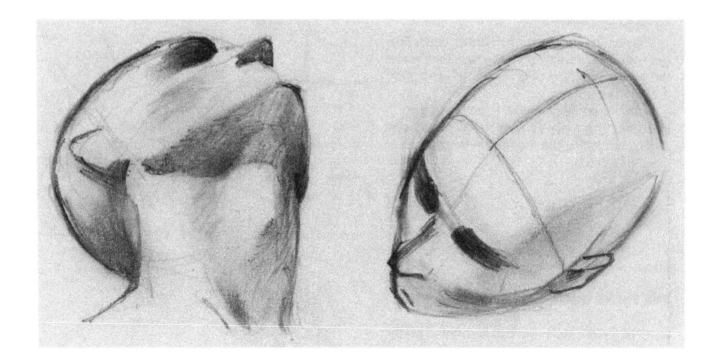

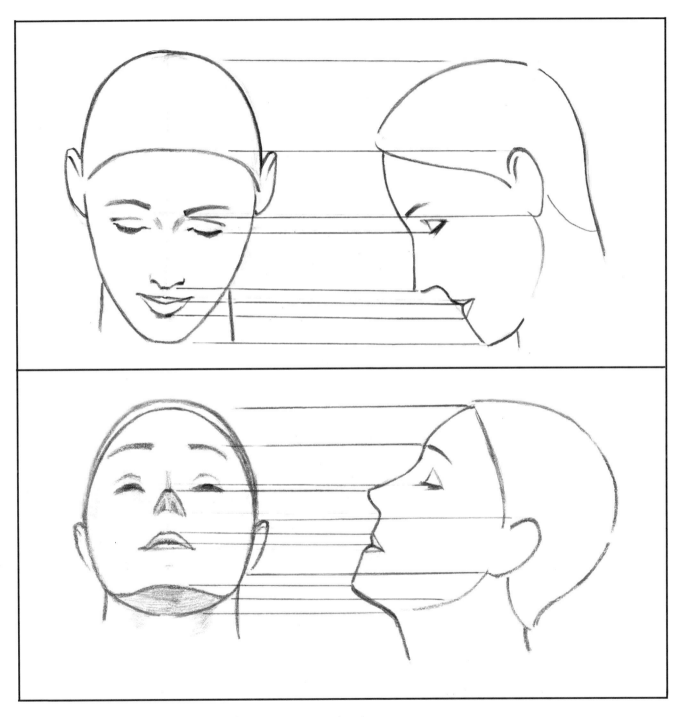

In the top views here, you can see the reference points on a head
angled down. In the bottom views, the head is angled up. Capturing
these distinctions is what makes an angled head look correct.

The Chin Point

The chin point and facial angle are important considerations when placing the head. When the chin is located properly in relation to the shoulders, half the battle is over. The other half consists of determining the size of the head. With those two problems out of the way, you can settle down to some serious drawing, because you know that the big problem—orienting the head—is behind you.

Don't guess at the point where the chin sits in relation to the shoulders, and don't change it from what you see unless you have a very good, logical reason to do so.

Check it by eye, but get it right or the whole figure will look wrong and you may not be able to correct the problem later.

Also be aware of the point at the pit of the neck where the two clavicles meet. It is a powerful reference point, along with the two muscles running up behind each ear, when placing the head and neck.

The Hand

The hands are so complex in their various shapes, sizes, and positions that we need to simplify them in order to understand them. First let me make a few points about their general overall shape.

- The basic shape of a hand can be considered an oval; the proportions of the oval differ greatly from one person to the next.

- The finger mass is roughly the same length as the back of the hand, but fingers look longer from the back of the hand because the knuckles are set back. Spread your own fingers to see what I mean. This makes the fingers look shorter in the palm view.

- The back of the hand is convex, and the palm side is concave.

- The wrist comes in at an angle so the hand is offset slightly, and that adds to the illusion of shortness of the back of the hand in relation to the fingers.

- The three rows of knuckles in the fingers are curved, with the knuckle of the middle finger being slightly forward from the rest.

- A line drawn from the knuckle of the middle finger back toward the wrist will be the high point in the arch of the back of the hand.

Before you begin to draw, take a good look at your hand from every angle.

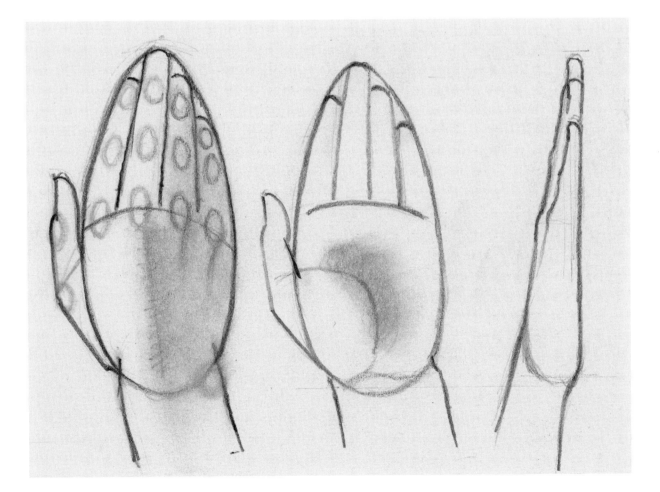

Simplify the Hand

Now let's get the hand down to a manageable shape, one that's easy to visualize and draw. In order to do that, we have to eliminate some of the complex parts and bring them back later when we are ready for them. So let's start by chopping off the fingers and thumb.

Now you have a simple wedge shape that is fairly rigid in itself, so we don't have something that changes shape on us each time we draw it. The wedge moves side to side slightly, and it bends forward and backward at the wrist; but it holds its own wedge shape pretty constantly. That makes it easy to draw in any position.

Remember that it is convex at the top, or back, and concave on the palm side. The wrist enters this wedge at a slight angle from the top. Try drawing this shape in various positions. Re-

The main part of the hand is a rigid wedge shape. That makes it easy to draw.

member, when the wrist bends, there is a definite curve going into a short, flat surface, the back of the hand. This needs to be decisive, not a rounded, characterless curve. Also keep in mind that, except for a straight-on view, the back of the hand is always flat from wrist to knuckle.

Once you get this wedge concept down and can draw it easily, we are ready to get more complex. You don't need anatomy for this kind of study. But you need to get a clear working knowledge of the way the hand is designed and how it works.

When you block in the hand using this method, you don't draw it the way it looks here; you only visualize it this way. What you draw are the two side lines and maybe a guideline for the knuckle arch.

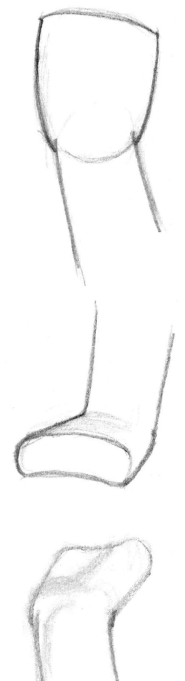

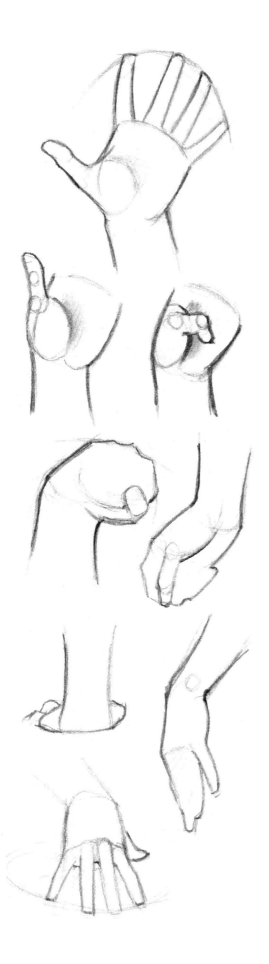

Adding the Details

Think about hands some more. The hand is capable of a huge range of motion. When the fingers are extended and spread out, they form a curve. The middle finger is the longest. The rest of the fingers curve slightly inward, toward the middle finger.

The thumb is attached on the palm side of the hand. Its motion actually begins at the joint where it connects with the wrist. The thumb can move forward from there, as well as sideways, but it can move backward only slightly. The drawings here demonstrate the thumb's full range of motion.

In many situations, it is possible to mass some, or all, of the fingers into one simple shape. Whenever it's possible, try to do that rather than drawing the individual fingers. If you have the right general shape, this approach is almost always better for looser, freer work than a carefully delineated drawing. Again, you want to think in terms of big shapes without unnecessary details.

There will be times when you have no choice but to draw all the fingers and the thumb, because the position of the hand does not allow for massing the fingers. In this case, you will need to visualize the fingers in varying degrees of foreshortening and overlapping.

An Even Simpler Approach

If you are still having trouble visualizing the fingers in their proper relationship to the wedge-shaped plane of the hand, here is the simplest way to capture them.

Instead of using lines around the fingers, take the broad side of your pencil or other tool, and put the fingers in with one simple stroke of tone. The three sketches at right show what this looks like. It is much easier to see the fingers this way. You can still mass fingers together where possible, to get the simple basic shape down first. Sometimes these broad strokes and massing are all you need in order to show the hand action in a rough sketch.

The sketches below were also done this way, by stroking in the finger shapes with a simple, flat tone. I carried them a little further, but in a rough sketch, it would have been better to leave them simpler.

You will find that many complex subjects can be broken down and simplified like this. Sometimes it's the only way you can understand something well enough to draw it clearly. The shapes in the hand are the one part of the body that is really hard to see without some help like this first. But eventually even they will come easier.

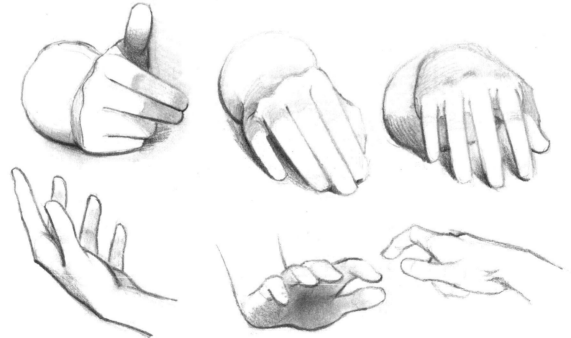

The Foot

The foot is much easier to simplify than the hand, and it is considerably easier to draw. But it still takes a good amount of study to understand the way it is put together. One would think that something as basic as the shape of the foot would be so simple to draw that it would require no knowledge other than to draw it as you see it. But the shapes are so subtle that if you don't understand the way they fit together, your drawings will probably resemble blocks of wood.

The foot is capable of a surprising amount of motion, but it holds its basic shape through all of its movements. That makes a simple basic conception of it very practical. Basically, it is wedge shaped, somewhat like the back of the hand. Think of a simplified shoe, with fairly straight but tapering sides. The drawings below illustrate this.

For a moment, forget about the arch of the foot and imagine a flat sole. Now see how easy it is to project this pattern on the floor, and to draw the wedge over it. This puts the foot solidly on the floor, a vital point in drawing a convincing figure. If you mess up here, your figure will look somehow unconvincing, and you won't know what is wrong with it.

On the following page, I will stop preaching and just show you drawings of some important facts about the foot. Study them and see if you can grasp the basic point behind each drawing. Now take off your shoes, but leave on your socks, the tighter and thinner the better. Sit in front of a mirror and draw your foot in every conceivable position. Draw, draw, draw! And turn the page.

The Structure and Action of the Foot

Study the shape of the feet and try drawing them in all positions. You can draw your own feet, but you will only be able to see them from one angle unless you use a mirror. Fortunately, family and friends are usually willing to do some foot modeling! If not, spend an afternoon at the beach with your sketchpad. You will be amazed at the variations of shape and size of feet, but they can all be reduced to recognizable basics.

Start with the wedge shape and draw it in different positions. Then enhance your work with more details. Once you have a good understanding of the form, you can add ankles and toes that will bring life to your figures. Even if you have always left your figures without feet, you will have them walking, dancing, standing on their own two feet with a little practice.

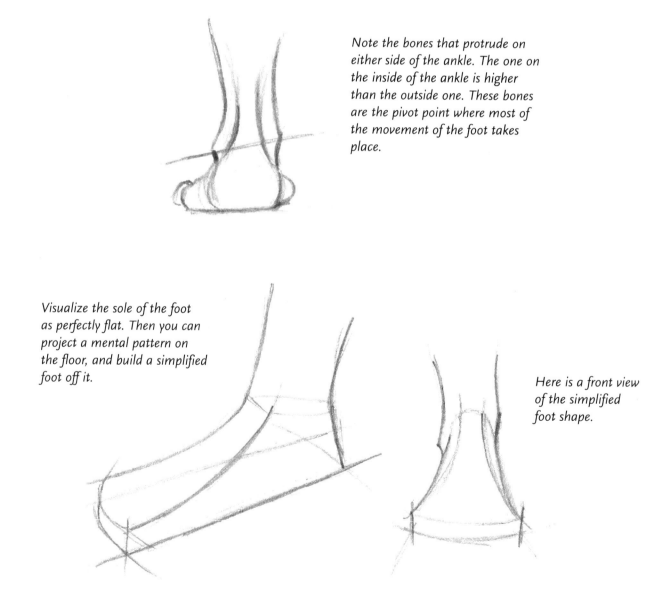

Note the bones that protrude on either side of the ankle. The one on the inside of the ankle is higher than the outside one. These bones are the pivot point where most of the movement of the foot takes place.

Visualize the sole of the foot as perfectly flat. Then you can project a mental pattern on the floor, and build a simplified foot off it.

Here is a front view of the simplified foot shape.

The central structure
of the foot holds its shape
through most of the movement
of the foot at the ankle pivot.
Only the toes move from the
second joint back from the tip
of the toes.

Note the pull of the tendons as
the toes are pulled upward.

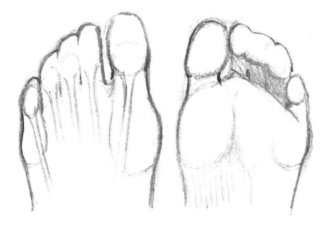

Here is one more look at
the simplified shape of
the foot. As you can
see, the smaller toes
are generally massed
together to form a
single simple
shape.

This view shows the top and bot-
tom of the foot, including the
tendon structure and the pads.

Conquer Your Weak Points

Heads, hands, and feet. These are the things that most artists really struggle with. You will often see a fairly competent drawing of a figure with these features badly done, and that destroys the whole drawing.

This brings me to a piece of advice that is so obvious and simple that I marvel at how few people actually practice it. And yet following this advice will propel your work forward faster than any technique or trick.

Here is the advice: Whenever you find a weak spot in your drawing, drop everything else and conquer that weak spot immediately. Make it a strong point.

We often carry our weak points around like the proverbial millstone, and we go through life struggling with them every time

we are forced to deal with them. Heads, hands, and feet are the millstones of many artists. But you cannot avoid them if you want to draw figures—they are an important, expressive part of every figure drawing. You can find just so many flowerpots to hide the feet of your model, and you cannot expect them to pose with their hands behind them every time!

When you are lucky enough to recognize a weak point, put it behind you. There is no surer way to overall improvement, and it's a powerful confidence builder. Even if it takes six months or more, take the time to study your weak point, to practice, and to get a grip on it. Then that weak point will be gone forever, and you will be a much better artist.

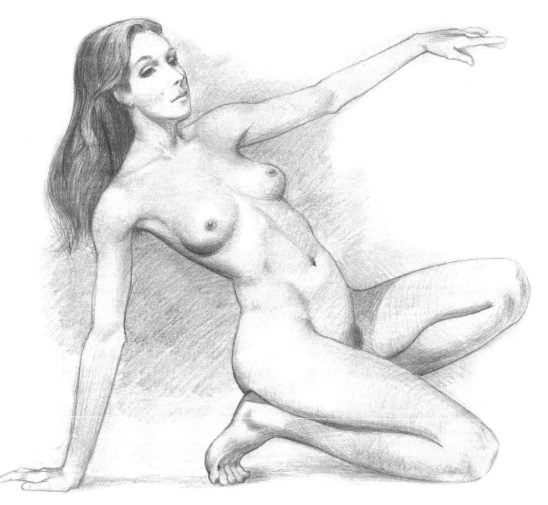

You can find just so many flowerpots to hide the feet of your model. If you identify a weak point, work to make it a strong point.

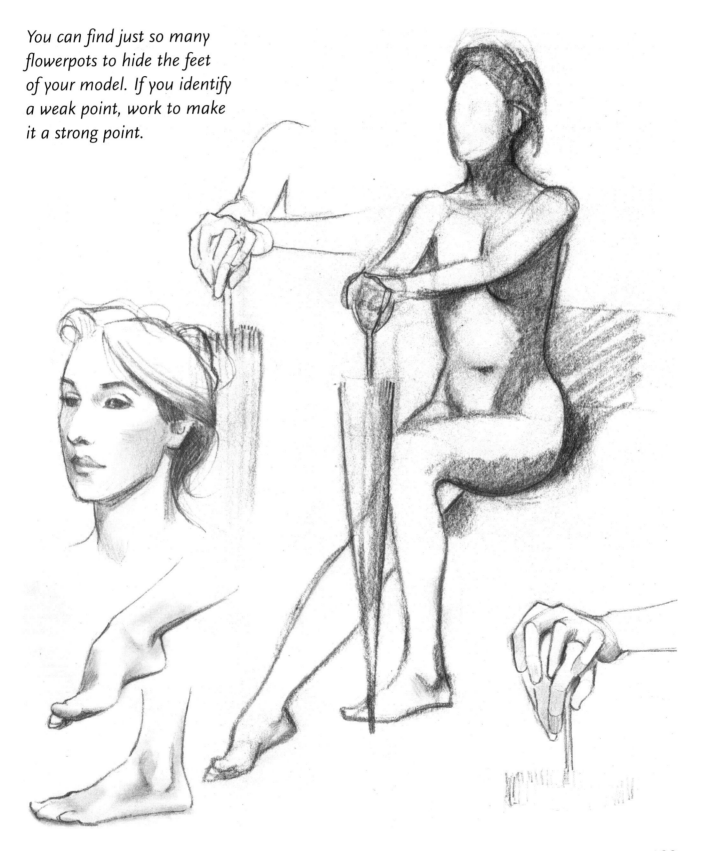

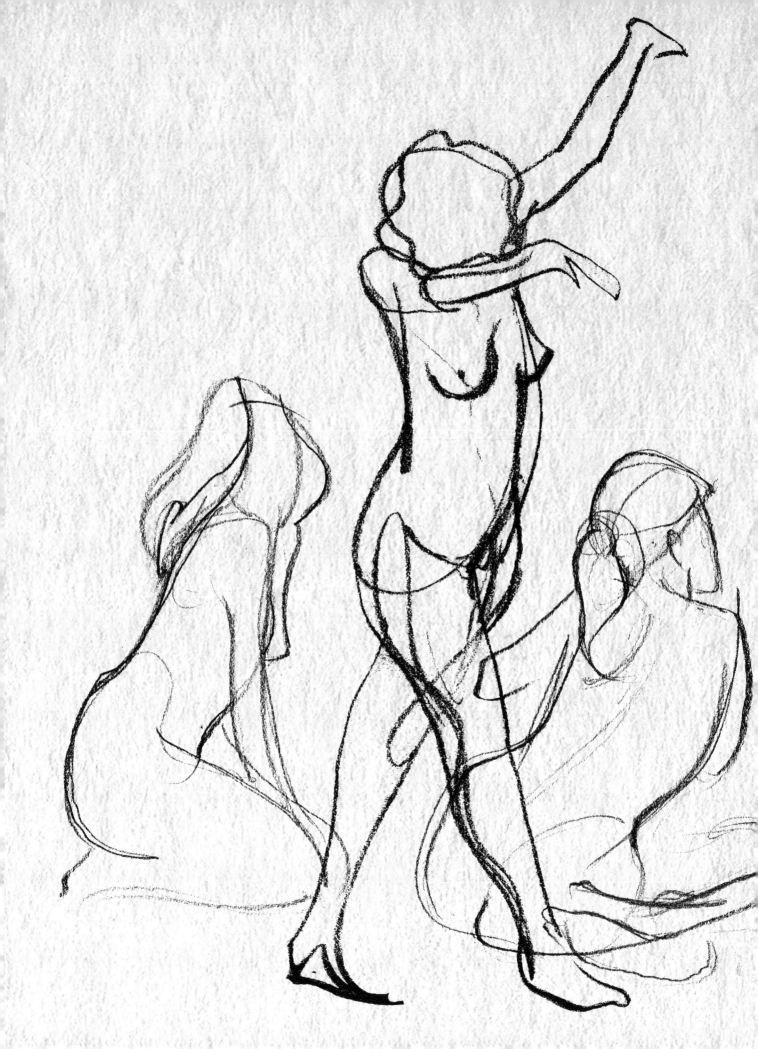

Break Free

Now let's see if you are ready to fly! Throw out your crutches and try your wings. Use your hard-won knowledge to enter the uncharted world of aesthetics. This is what all your study has been leading to. Happy drawing!

Work on the Edge

If you have made it this far, you undoubtedly have that special drive to be an artist. Some people call it talent. Something is pulling you to express yourself in a unique and special way. This drive will take you unerringly where you were meant to go, if you simply let it. But you must follow it; you cannot lead it without going astray. You must be true to yourself. Don't force yourself to work in a particular style simply because the rest of the world is doing it.

At this time in history, the art world is loaded with tastemakers who are motivated by something other than the sincere desire to raise the standards of serious art. So you are pretty much on your own to sift through the stuff that is just trying to shock you and find the genuine attempts to celebrate the beautiful things of our world. If you like something, then it is probably right for you at this time. You cannot fool yourself. If you have what it takes to work in the more abstract, nonobjective ways, you will know it; and then, by all means, do it. But if not, go where your inner drive takes you. It may or may not make you rich, but it is the best you can get from your measure of talent. This is the only way to nirvana.

All of our study has been necessary to drive the fundamentals of seeing and thinking into your subconscious so they pop up automatically when needed, like a reserve fuel tank. It will be hard at first to toss out your crutches, but now it is time to stop measuring everything, if you haven't already. Stop consciously thinking about perfect proportions or anatomy and take from the model only the essence as you see it. Feel it, give your creative brain full reign, and ruthlessly shut out your intellectual brain. Let it function only when you need it.

If you still can't get a reasonable copy of the thing before you, you have missed something along the way. No one can simply read this book, or any other, and begin serious drawing right away. You need to put these principles to work for at least a year, and probably more, if they are to work for you automatically. Plumbers and carpenters take several years to learn their professions. Doctors take many more. Some art schools take four years, and many thousands of dollars, to give you much that you won't even use.

Give yourself a break and concentrate on the information in this book long enough for it to help you—because it will. If necessary, go back to the beginning and start over. Don't be one of those artists who draws half-heartedly for a lifetime and ends up no better than when he or she started. Real talent cannot be inhibited by serious study.

You have found out that lines, shapes, and patterns talk to you. They have a language all their own. Everything is made up of these basic elements, so you are not limited to drawing the figure. It was logical to start out with the figure, because it is us, as I said earlier. But by now you surely realize that all drawing is drawing, whether you are drawing the figure or anything else. All the same principles apply. If you can draw the figure, you really can draw anything. There is an unlimited world of subjects out there to explore, and there is no reason to limit yourself unless you choose to.

The rest of this closing chapter is basically a kind of sketchbook of some of my drawings from the workshops. They are nothing more than honest attempts to tell you what I was seeing at the time. No thought was given to whether these drawings had a contemporary flair or any other artistic merit. Because of this attitude, nothing clouds the message that gets to you, and I can honestly say that I "flew" while doing them. That's my idea of nirvana.

This Conté crayon drawing was made from a sketch from a life drawing session. I was struck by the strong pattern of darks, and I made several quick impressions before getting this one.

A Designer's Dream

I enjoy creating compositions of several poses into one drawing. The figure is a designer's dream; it practically designs itself and breaks up your page naturally.

Sometimes fellow students
make great models, too.

Short Poses

For me, ten minutes is the optimum time for getting my best drawings; five-minute poses are good, too. In these short periods, the model can hold more inspired poses and can keep up her enthusiasm for the pose. The feeling of energy is contagious and spreads throughout the classroom.

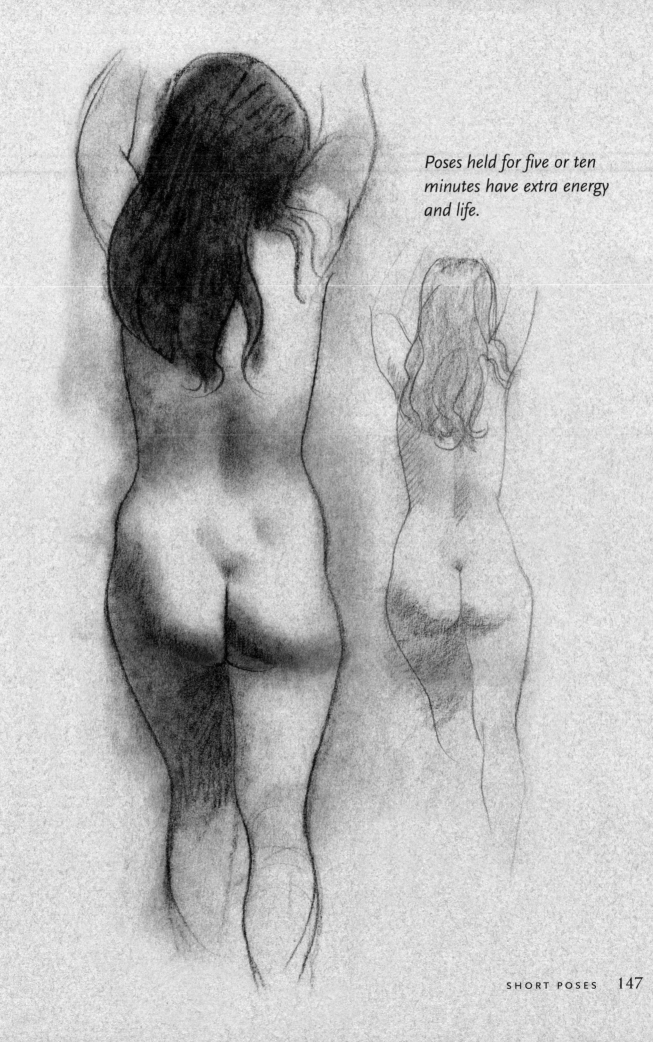

Poses held for five or ten minutes have extra energy and life.

Mood and Emotion

Mood—yours *and* the model's—enters the picture when you free yourself. These three drawings express very different emotions, but I didn't consciously set out to put those moods down on paper. I only saw them later.

The love of posing is shown by this model.

148

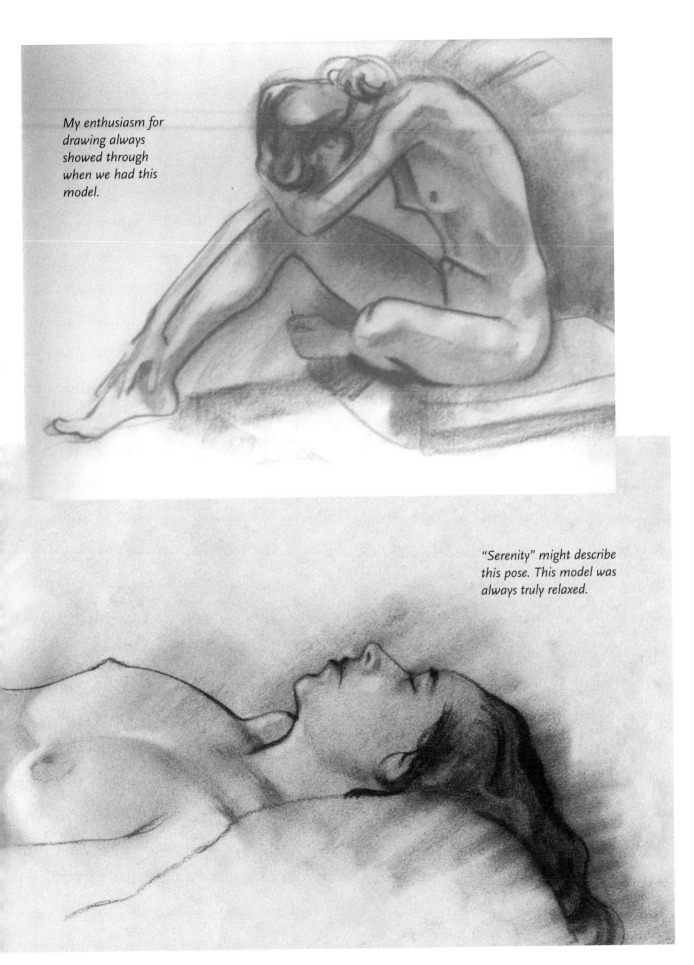

My enthusiasm for drawing always showed through when we had this model.

"Serenity" might describe this pose. This model was always truly relaxed.

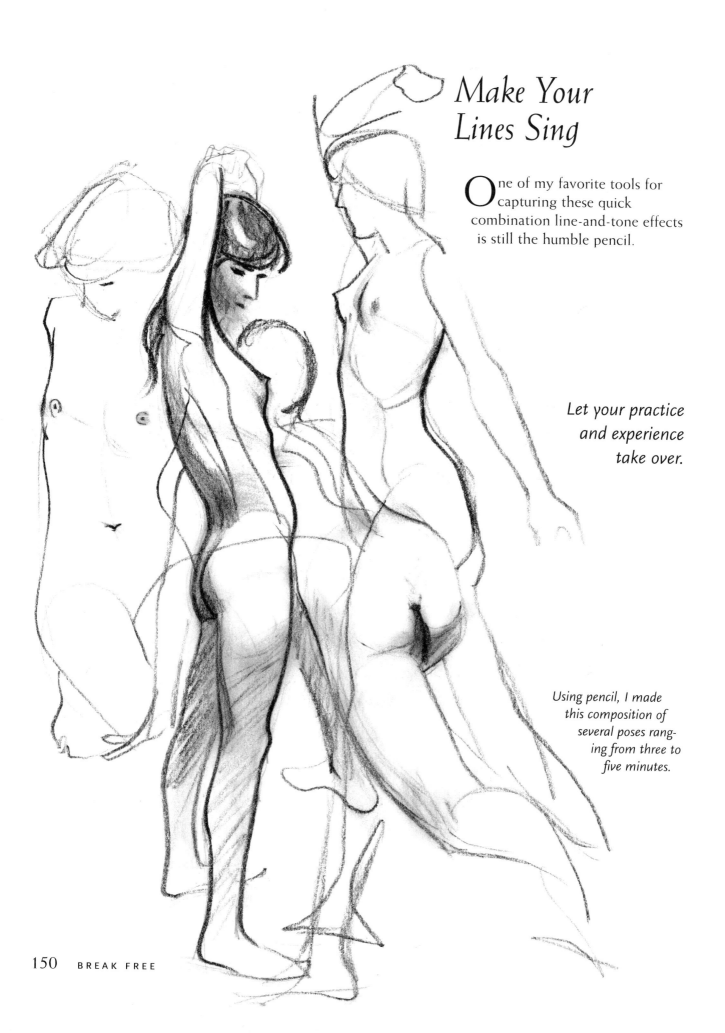

Make Your Lines Sing

One of my favorite tools for capturing these quick combination line-and-tone effects is still the humble pencil.

Let your practice and experience take over.

Using pencil, I made this composition of several poses ranging from three to five minutes.

These one-hour poses were sketched in charcoal. Simple lighting lends power to the drawings.

An understanding of light helped capture this pose.

Applying the basic head map made it much easier to get this likeness.

Using Your Knowledge

As you work and gain experience, you will always be able to put your knowledge to use. Working with shapes, light, heads, hands, and feet, line—whatever you have studied— gives you background that cannot be absorbed in any other way. Breaking free is gathering all of your understanding and letting it fly free.

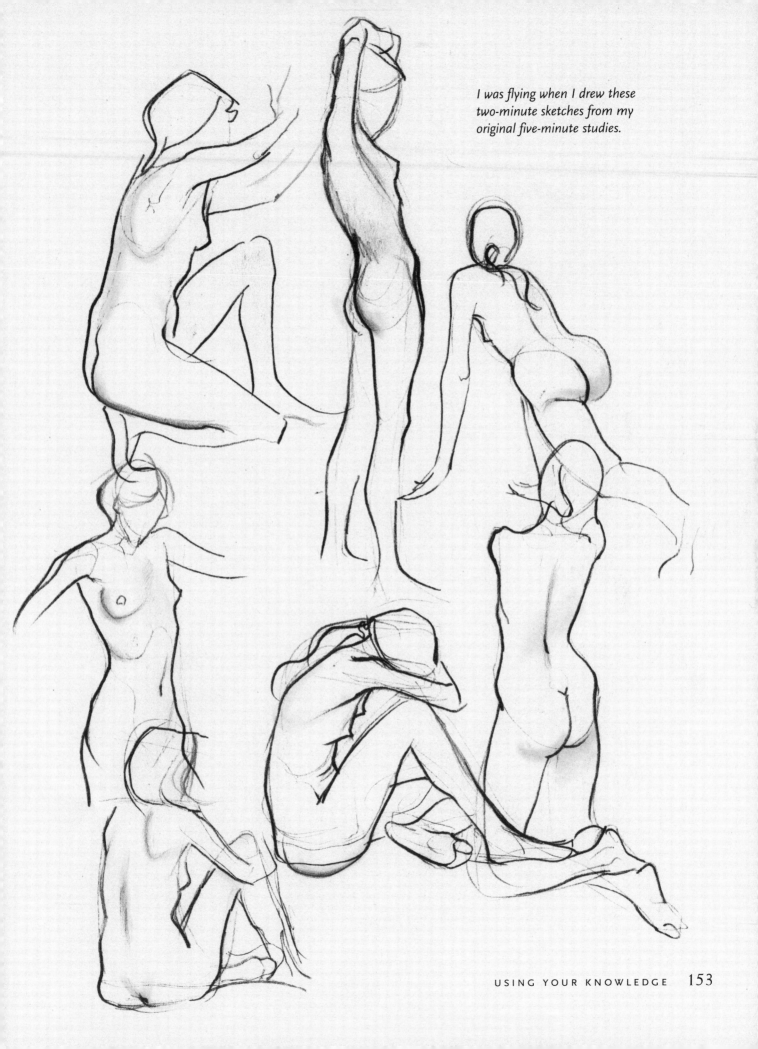

I was flying when I drew these two-minute sketches from my original five-minute studies.

With a solid foundation in working with shapes, a position like this becomes an enjoyable puzzle rather than a frustrating hurdle.

Walk Before You Fly

Most of us look with awe at the drawings of the Old Masters. Those works are timeless, made by the finest artists of their generations—artists learned from and contributed to the accumulated knowledge of all the generations before them, benefiting from a solid foundation and building one for those who followed.

At some point in the mid-nineteenth century, artists began the search for other ways to express themselves. There had always been innovators, but that was when the search began in earnest. The camera had made realism in art seem almost redundant—and so began a new and very exciting chapter in the history of art.

A major consequence of this new emphasis on novelty was the elimination of traditional methods of teaching art in most art schools.

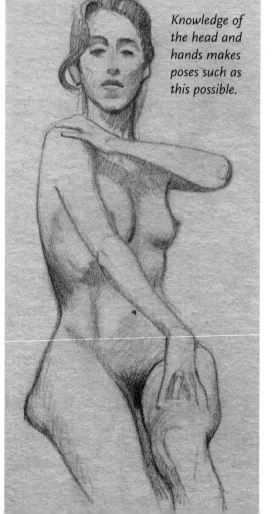

Knowledge of the head and hands makes poses such as this possible.

The results are obvious. Only the very few schools that continued to teach the hard-won knowledge of the past were able to consistently turn out students who could earn a living in the fields of illustration or in anything but the rarified market of the avant-garde. And so a great many artists with potential became plumbers, carpenters—anything but artists or illustrators.

The vast majority of people cannot understand or appreciate the so-called "fine arts" of today. These are the very same people who constitute the major market for reasonably priced art. Given that art is a language, a way of communicating, it defies logic why anyone would speak in Greek when addressing an English-speaking audience and then complain when no one understands him or her.

A whole new culture has grown from this new art that speaks only to a selected few. Throughout history, charlatans have taken advantage of those who need someone else to tell them what they should like. It is interesting that most of the artists who have withstood the test of time acquired the basic, traditional skills of drawing before branching out in other directions—Degas, Modigliani, Matisse, Picasso, van Gogh, and Klimt, to name only a few.

You must start from a solid base if you are to move into uncharted waters. Nothing is so empty as the search for newness, or the attempts to be contemporary when you are working from a wobbly foundation.

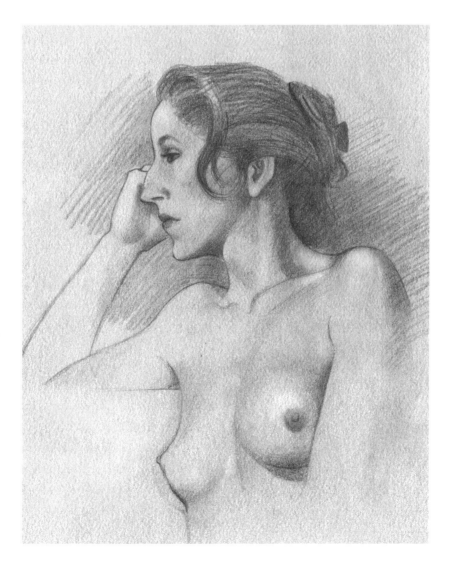

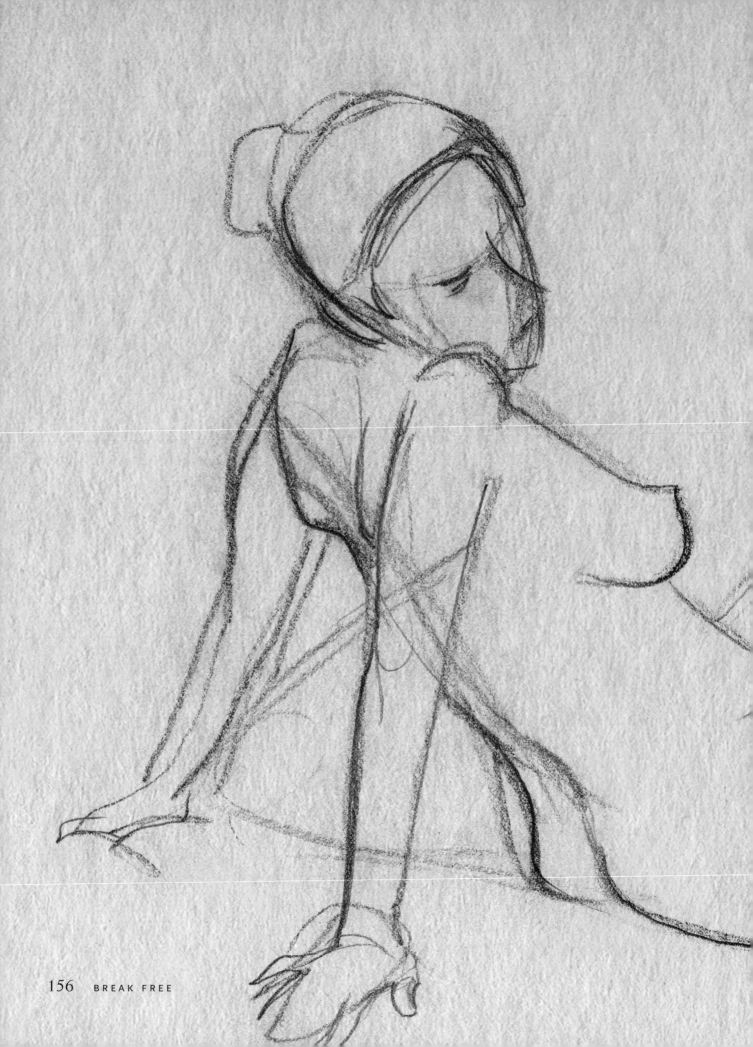

The Fire That Burns Within

To me, talent is the unquenchable desire to do something better, whether it's art, music, or driving a truck. You simply cannot help yourself; you must struggle to get to an unreachable goal.

If your talent is art, consider yourself to be among the luckiest people in the world. You will never receive a more precious gift, and only a fool would waste it.

You probably will never be another Rembrandt. You wouldn't want to be, anyway.

But you can get just as much pleasure (and frustration) creating your art as he did in creating his. Believe it or not, he was further from reaching his goal than you are right at this moment. This is true because, the more you learn, the more you realize there is to learn. The goal gets further away as you progress.

The study of art is endless. Each time you open a door, there are ten more begging to be opened and explored. After you master the technical side—the handling of tools and materials; the study of anatomy, perspective, values, color, and accurate perception—you enter the endless world of aesthetics.

For centuries, humans have attempted to analyze and categorize the things in this realm with little success. Rules of design or composition are no sooner made than they are successfully broken. This makes for a lifetime of exciting exploration and experimentation.

There is no way to measure the great pleasure I get from a simple walk in the fields or woods—or almost anywhere that the artist's mode overpowers me. It gets more intense as I grow older. When the realization hits me that many people miss these things as they go through life, I know that this is a special gift. If you have this fire burning inside of you, keep it alive. You are indeed one of the lucky ones.

Index

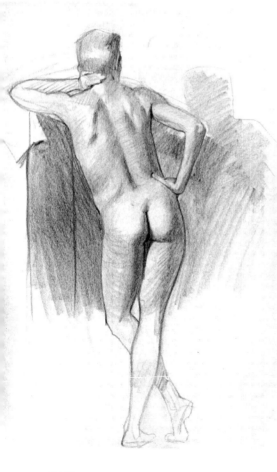

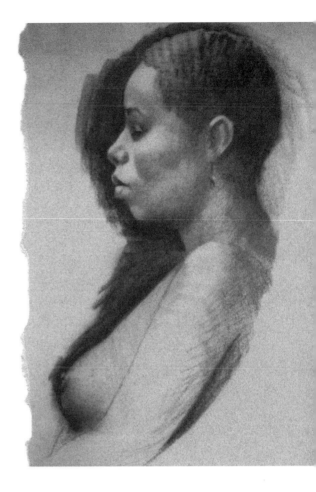

Acknowledgments

Thanks to the unknown editor who saw some potential in my manuscript and to a pair of very professional editors, Joy Aquilino and Laaren Brown, who quietly managed to get the rough edges off of it, and to a very talented designer, Patricia Fabricant, for adding a touch of class. Thanks also to Don Nestler, who introduced me to the mysteries of the computer, and a special thanks to Linda for patiently, and tactfully, showing me how much I needed to learn.

Finally, thanks to all those who encouraged me to write this book. I refrain from mentioning your names for fear I might miss someone out of a sizable group. There would be no book without you.

Further Reading

Albert, Greg, editor. *Basic Figure Drawing Techniques.* Cincinnati, Ohio: North Light, 1994.

Bridgman, George. *Bridgman's Complete Guide to Drawing from Life.* New York: Sterling, 2001.

Edwards, Betty. *The New Drawing on the Right Side of the Brain.* New York: Jeremy P. Tarcher: 1999.

Goldstein, Nathan. *Figure Drawing: The Structure, Anatomy, and Expressive Design of the Human Form.* Upper Saddle River, N.J.: Prentice-Hall, 1998.

Hale, Robert Beverly. *Drawing Lessons from the Great Masters.* New York: Watson-Guptill, 1989.

———. *Master Class in Figure Drawing.* New York: Watson-Guptill, 1991.

Hogarth, Burne. *Dynamic Figure Drawing.* New York: Watson-Guptill, 1991.

Parramon, José. *How to Draw the Human Figure.* New York: Watson-Guptill, 1991.

Ryder, Anthony. *The Artist's Complete Guide to Figure Drawing.* New York: Watson-Guptill, 2000.